A Century of Silver

THE COURTAULD FAMILY

OF SILVERSMITHS

1710–1780

HELEN BRAHAM

Courtauld Institute Gallery
London

All pieces are London sterling standard silver unless
identified as Britannia standard (see further pp. 10–11).

Dimensions are given as height × width × depth; weight is
given in grams and troy ounces.

Object numbers correspond to identifying numbers in the
display cases in the Courtauld Institute Gallery:
A=Augustin's table
S=Samuel and Louisa's table
D=Buffet table
B=Buffet shelves.

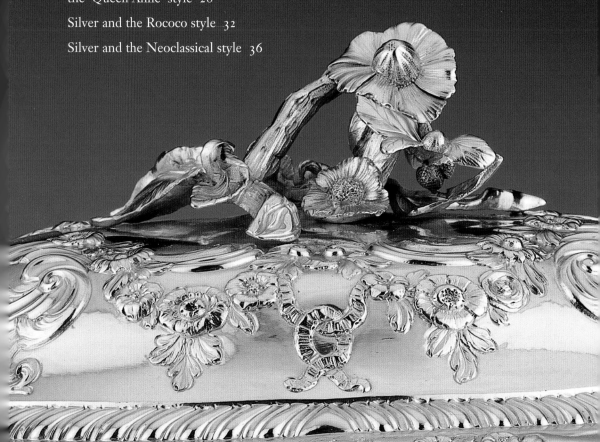

The Courtauld silver collection, the Courtauld Institute and Akzo Nobel

The silver collection described in this book is unique in representing the work of three generations of a single family. It was produced during the eighteenth century by the descendants of Augustin Courtauld, who, as a Protestant, or Huguenot, had been forced to leave his native France and settle in London. His son Augustin, grandson Samuel, Samuel's widow Louisa Perina, Samuel's apprentice George Cowles and son Samuel II were responsible for the silver here, ranging in date from 1710 to 1779. They were successful, prolific and renowned silversmiths or, properly speaking, goldsmiths, and were prominent members of the Huguenot community which contributed so notably to the arts and skilled crafts, commercial enterprise and public life in eighteenth-century England. At the end of that period the family turned to silk-weaving, another typical Huguenot industry; from this grew the famous textile company.

Their descendant, Samuel Courtauld, founded the Courtauld Institute of Art with Lord Lee in 1932 and formed the magnificent collection of French Impressionist and Post-Impressionist paintings. From 1921 to 1946 he was chairman of the textile company Courtaulds Ltd, later Courtaulds plc. Soon after his death in 1947 the company embarked on acquiring this collection of silver, assembled during the succeeding half century.

When in 1990 the Gallery moved to Somerset House, Courtaulds plc transferred the collection to it on loan. In 1998 Courtaulds became part of the international company Akzo Nobel nv and the responsibility for the collection passed to it; with great generosity Akzo Nobel has extended the loan indefinitely. It is to these two companies in succession that the Courtauld Institute Gallery is indebted for this fortunate juxtaposition of two aspects of Courtauld achievement.

This book is published to coincide with the display of Courtauld silver opened in June 2003 at the Courtauld Institute Gallery in Somerset House, with the generous support of Akzo

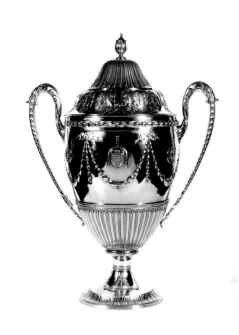

B11 Cup and cover, Louisa and Samuel II, 1778–79

Nobel, a grant from the Heritage Lottery Fund and donations from the Goldsmiths' Company and a private benefactor. The book is designed to accompany the display and concludes with a catalogue of the objects. It both surveys the achievements of the Courtauld family of silversmiths and explains general aspects of an outstanding century of English silver.

The Huguenot émigrés

The persecution of Huguenots, or Protestants, by the Catholic establishment was central to the bloody history of sixteenth-century France and prompted Protestant emigration from then onwards. In 1598 the Edict of Nantes guaranteed religious freedom, but under Louis XIII and Louis XIV this assurance was eroded: decades of increasing violence culminated in the Revocation of the Edict of Nantes in 1685, ensuring a flood of over 200,000 emigrants to tolerant countries. An added incentive for goldsmiths to leave France was Louis XIV's ban on their work, to finance his wars.

Some fifty thousand Huguenots eventually settled in London, among whom were members of the Courtauld family. They formed a sober, close-knit society, intermarrying, retaining their own customs and language, and supporting their own churches and institutions, some of which survive today. Barred in France from the higher professions, they brought with them a wide range of skills and an industriousness which benefitted Britain's artistic and economic progress. It also challenged indigenous craftsmen, and an attempt was made, with limited success, to exclude such 'aliens' from the Goldsmiths' Company. Official policy, religious views and general sympathy encouraged the immigrants, while their workmanship and knowledge of French taste invited the patronage of fashionable society. It was a Huguenot goldsmith, Nicholas Sprimont, who helped to launch porcelain manufacture in Britain and another, Paul de Lamerie, whose mark is the most revered on silver of the period. Huguenot smiths dominated the craft throughout the Courtauld dynasty's participation.

Certain craftsmen settled in particular districts, dictated partly by restrictions for 'aliens'. The most varied group resided in Soho, where luxury trades, including gold- and silversmiths, jewellers, clockmakers, furniture makers and the fashion industries, flourished in proximity to the court and to government. Weavers congregated in Spitalfields, which became famous for its silks. Interrelated crafts worked closely together, giving each other commissions, providing outworkers, apprenticing their sons to friends and family. The St Martin's Lane Academy where the sculptor Roubiliac taught, and Hubert Gravelot's drawing classes there and at his school in Covent Garden, were closely associated with Huguenot artists and craftsmen, while the fashion for the Rococo style fostered in that circle attracted Huguenot initiative and skill. Huguenots were still prominent in the luxury trades during the reign of George III.

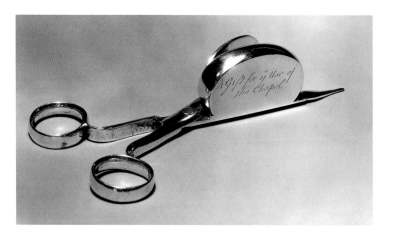

A2 Candle snuffers, Augustin, 1715–16

Augustin Courtauld (1685/86–1751)

Augustin Courtauld was born at St-Pierre on the Ile d'Oléron, near La Rochelle, the historic centre of French Protestantism on the Atlantic coast. His mother Julie Giraud (or Giron) died around the time of his birth in 1685–86. The infant remained in St-Pierre when his father, also Augustin, fled to England in 1687, settling in London as a wine cooper. There he married his second wife, the Huguenot Esther Poitier (or Potier), by whom he had another son, Peter (1690–1729). The young Augustin joined his father in London nearly ten years later and was granted citizenship in 1696.

In 1701 he was apprenticed to the Huguenot Simon Pantin, who until that year had trained under Pierre Harache the elder, the first Huguenot immigrant to be admitted to the Goldsmiths' Company. Augustin's half-brother Peter was also apprenticed to Pantin from 1705 to 1712, married Judith Pantin and registered his Britannia mark in 1721; no silver marked by him has yet been found.

Augustin was made free of the Goldsmiths' Company by service on 20 October 1708 and established himself as a plateworker in Church Street (or Court), St Martin's Lane. In 1729 he moved to 'Shandois' Street, now Chandos Place, where he was established for the rest of his career. In 1709 he married Anne Bardin; they had eight children, all baptized at the Huguenot chapel in Orange Street. He registered his first mark, *CO* with a fleur-de-lys (as used in Paris) for Britannia silver, in 1708, continuing to use this mark for Britannia silver until at least 1731; he registered his second mark, *AC* for sterling silver, in 1729 and his third, *AC* in script capitals, in 1739. Augustin may already have retired from the business when his son Samuel registered his own mark in 1746. He and his wife died in 1751 and were buried at Chelsea Old Church (then St Luke's).

The ceremonial standing salt of the Corporation of the City of London (1730–31, Mansion House) is Augustin's most famous surviving work in England. His reputation depends largely on a prolific sequence of domestic

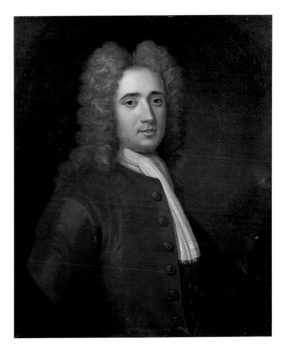

Augustin Courtauld, attr. to Hans Hysing, *ca.* 1730–40
Oil on canvas, 77 x 63.5 cm. Private collection

silver, notably for the new hot drinks (see pp. 12ff.), and of ceremonial cups, but he also made a wider range of pieces for the Russian court. Surviving items include a silver table now in the Kremlin at Moscow, while in the Hermitage at St Petersburg are contributions to significant toilet services and a massive and important Rococo centrepiece of 1741–42, which confirm his importance among goldsmiths of the age.

Augustin's mark (1), 23 December 1708

Augustin's mark (2), 7 October 1729

Augustin's mark (3), 6 July 1739

Samuel Courtauld I (1720–1765)

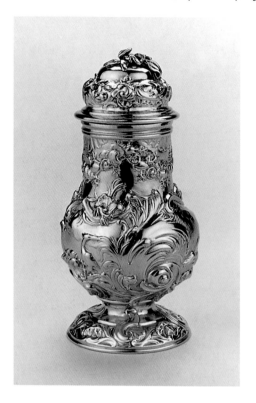

D12 Spice canister, Samuel, 1750–51

Samuel Courtauld was born on 10 September 1720 and baptized at the Huguenot chapel, then called Leicester Fields Church, in Orange Street behind the present National Gallery. He was the second son of Augustin and his wife Anne Bardin. In 1734 he was apprenticed to his father, whose four other apprentices were all from Huguenot families. From 1741 he worked for his father as a journeyman and in 1746 he registered his first mark at Goldsmiths' Hall, S.C with the sun in splendour. He still worked from his father's premises in Chandos Place, off St Martin's Lane, at the sign of the Rising Sun, having perhaps taken over the workshop.

On his father's death in 1751, with an inheritance of £400 and his father's tools and patterns, he moved to the sign of the Crown, 21 Cornhill, a more prestigious address facing the Royal Exchange in the City of London. There he registered his second mark, S.C, for small work. His trade card describes his business there: 'Makes & Sells all sorts of Plate, Jewels, Watches, & all other Curious Work in Gold & Silver, at the most Reasonable Rates. N.B. Likewise Buys & Sells all sorts of Second-hand Plate, Watches, Jewels, &c.'

In 1749 he had married Louisa Perina Ogier, daughter of Peter Ogier the younger, a prominent Huguenot weaver of Spitalfields, at St Luke's Church, Old Street, Finsbury; they had eight children. He was admitted to the Livery of the Goldsmiths' Company in 1763, at about which time he registered a third mark, SC in script (the register for that period is destroyed). He died two years later at the early age of forty-five, leaving all his property to Louisa Perina, and was buried at Chelsea Old Church (then St Luke's).

There are notable pieces of silver marked by Samuel in the City of London: the silver-gilt beadle's staff head commissioned by the Clothworkers' Company (1755–56), and a remarkable hot-water urn acquired by the Goldsmiths' Company (1760–61). Also like his father, he is celebrated for silver sent to the Russian court, contributing many pieces to the massive so-called Pleshcheyev service, including coffee and tea-pots and a shaving dish amongst surviving articles at St Petersburg.

Samuel's mark, 6 October 1746

Samuel's mark, 23 November 1751

Mark attributed to Samuel (unrecorded), *ca.* 1763

Louisa Courtauld (1729–1807), George Cowles (died 1811), and Samuel Courtauld II (1752–1821)

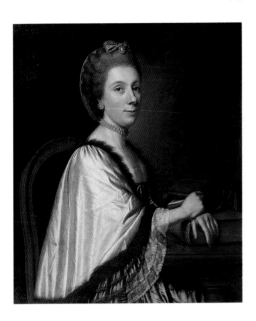

Louisa Courtauld, attr. Nathaniel Dance, *ca.* 1765
Oil on canvas, 76.5 x 63 cm. Private collection

Louisa Perina Ogier was born in 1729 into an important Huguenot family from Bas Poitou, where she was born. Her father Peter Ogier the younger was a silk-weaver in Spitalfields. The dynasty, connected with at least twenty-five other Huguenot families, operated in every branch of the silk industry. At the age of twenty she married Samuel Courtauld at St Luke's Church, Old Street, bore him eight children and was widowed in 1765 at the age of thirty-six. Samuel bequeathed his property to her and she carried on the business with evident success. A portrait (above) shows her as a lady elegantly dressed in the fashions of around 1765, without the tokens of widowhood and therefore presumably immediately before Samuel's death. Her hands rest confidently on a large book, conceivably relating to the family business.

In that year Louisa apparently registered her first mark (unrecorded), *LC* in a lozenge, producing objects under that mark until 1768, when she went into partnership with George Cowles, apprenticed to her husband in 1751.

In the same year they first used their joint mark (unrecorded), *L.C/G.C*, and George married a niece, Judith, daughter of Samuel's sister Anne and John Jacob, also a silversmith. It was clearly a highly successful partnership and under that mark work of considerable individuality and distinction was produced. In 1777 Cowles moved to Lombard Street, registering his independent mark, and Louisa entered her third mark, *LC/SC*, jointly with her eldest surviving son Samuel II, then aged twenty-five; there is no record of his previous apprenticeship. Little survives with this mark and their candlesticks (D1) and the important silver-gilt cup (B11) are rare items. In 1780 the business in Cornhill was sold and Samuel emigrated to America to become a merchant; he married Sarah Norris Wharton in Philadelphia and died near Wilmington in the State of Delaware.

George, the only other surviving son (1761–1823), was apprenticed to a silk throwster in Spitalfields, inaugurating the Courtauld connection with the textile industry. He married Ruth Minton in New York State and died at Pittsburg; their son Samuel III settled at Gosfield in Essex in 1854. Louisa retired to Clapton, Essex, and was buried at Christ Church, Spitalfields, although her remains were recently exhumed and reburied among the family graves at Gosfield.

Louisa's mark (unrecorded), used 1766–68

Louisa's and George's mark (unrecorded), used 1768–77

Louisa and Samuel II's mark, 16 October 1777

How silverware was made

Apart from the introduction of a degree of mechanization, notably the 'flatting mill' in the 1720s, silversmiths in the eighteenth century used age-old methods, little changed today. The most common way of forming a vessel is 'raising', by which a sheet is given its shape by laborious hammering on a 'stake' or anvil; a shallow dish is similarly formed by hammering a disk against a wooden surface, a process known as 'blocking'. Creating a large flat sheet requires the greatest skill. The metal is worked cold but, since hammering makes silver brittle, the metal must be 'annealed' by heating and cooling repeatedly to keep it malleable; it is then 'planished' or smoothed with light hammering. Straight-sided vessels are formed from sheet metal with a soldered seam.

Casting is used for small additions, such as feet or a spout, or for shapes such as candlesticks or handles and finials. When making such items by the 'lost wax' method, a wax model is encased in a clay or plaster mould; this is then heated to remove the wax and molten silver is poured into the void thus formed. With sand-casting the model is impressed into compacted sand to form the mould. 'Die stamping', a technique significantly improved during the eighteenth century, means forcing silver into a hollow shape with a punch of complementary shape.

Numerous other techniques are employed for decoration. The piece can be 'embossed', that is, the design is 'repoussé' by being hammered in relief from the reverse or interior, then 'chased' from the front to put in the detail, using tools that do not remove metal. An example is the fox-mask stirrup-cup (D5). In 'engraving' metal is removed by cutting the design into the surface with a sharp burin or graver. From the 1770s 'bright-cut' engraving was introduced and made sparkling faceted effects possible. 'Matting' creates a contrasting dull surface by repeated punching. Piercing was done with a fret-saw and file or punch until the late eighteenth-century invention of the mechanical 'fly-punch'. Separately cast feat-

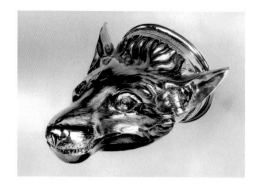

D5 Fox mask stirrup cup, Louisa and George, 1773–74

ures, including 'cut-card' decoration (see pp. 29–30), can be applied with solder.

After assembly, finishing entails polishing with abrasives, to eliminate seams and roughness and achieve reflective surfaces, and burnishing. The piece may be gilded or parcel-gilt (partly gilt), to emulate solid gold or to protect against damage caused by salt or wine; with mercury-gilding the surface is coated with an amalgam of gold and mercury, then heated (causing deadly fumes) to dissolve the mercury and deposit the gold. Assaying and hallmarking (see pp. 10–11) completed each piece.

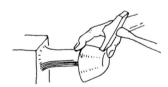

Raising a bowl on a stake with a hammer

Blocking a disk of silver on a wooden surface

How silverware was marketed

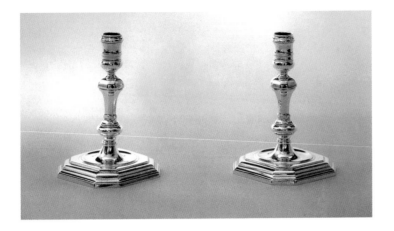

A16 Pair of tapersticks,
Augustin, 1718–19

It is commonly believed that the silversmith's mark, like the artist's signature, proves his authorship of the piece, indicating his creative rôle in its design and finish. This is to misunderstand the purpose of the maker's mark, which was to identify the sponsor who brought the piece to the Goldsmiths' Company's Assay Office, to be tested by the cupellation method. The 'maker' should be understood as an entrepreneur running a business involving a number of specialist craftsmen and -women on his or her own premises and where necessary employing outworkers and additional craftsmen and artists; John Jacob, for instance, may have supplied the baskets and candlesticks in which he specialized to his father-in-law Augustin Courtauld. Goldsmiths also cooperated with each other in the production of large services, such as Russian court orders.

Augustin, Samuel the elder and George Cowles had all served their terms of apprenticeship before registering their marks and were therefore themselves skilled craftsmen. Louisa, in spite of her mark, was not a silversmith in the practical sense, and there is no record of Samuel II's apprenticeship. Each, however, would have been generally responsible for the silverwares bearing the marks which made the Courtauld family one of the most famous in the craft. Many firms specialized in certain products, or acquired a reputation for a certain style: Augustin, for instance, apparently catered for the more conservative patron, while Louisa must have acquired a reputation for avant-garde Neoclassical pieces. Special commissions presumably received closer personal attention, not necessarily in the actual making but in the employment of particularly skilled artists such as a well-known modeller or engraver.

Trade cards survive which list the varied products sold from the premises (see p. 6), and some of these would obviously need further specialist skills. An existing bill of Louisa's for "4 second hand Desert [sic] spoons" illustrates the modest business carried on concurrently with grand commissions. Very few accounts survive, but there are trade ledgers from 1735 onwards of George Wickes, in Panton Street, off the Haymarket, and his later partner Edward Wakelin which give exceptional insight into the organization and specialization of such a company, which would act as co-ordinator and retailer. The shop itself, as pictured on trade cards, would have been spacious and elegant with glass-fronted display cabinets to lure customers and large windows allowing good daylight, a legal requirement for goldsmiths as a safeguard against fraud. The craft's concern with ensuring consumer protection dates from the Middle Ages, and marking began in 1300.

Silver history and hallmarks

Most silver derives from lead ores, from which it has been extracted in the Near and Middle East since around 2500 BC. By the first millennium BC it was being mined in Spain, which was the most important supply at the time of the Roman Empire. In medieval times central European deposits in Silesia were exploited. These resources were augmented by recycling silver objects, a practice characterizing its use for many centuries. In the sixteenth century Spanish conquest of the Americas revealed silver ores in Bolivia, Mexico and Peru, and Spanish silver affected both silversmiths' practices and the whole European economy.

Vast deposits found in other parts of the world in modern times have devalued the metal, but its traditional significance still lends it an aura far exceeding its present cost. Its original value was based on its rarity, beauty and practicality. It is malleable but, unlike gold, is tough enough when alloyed to be useful. Extremely durable, it could be constantly refashioned while retaining most of its value. It conducts heat, leaves no taste in food and was long known, though without scientific understanding, to be anti-bacterial, and the preferred material for cooking utensils.

Holdings of gold and silver constituted from early times the economic foundation of many countries. Coins made from the precious metals were a nation's currency and could be melted down to be invested in artefacts; conversely, in times of need the artefacts could be converted into currency. This situation arose notoriously in late seventeenth-century France, when Louis XIV's continuous wars required the enforced melting down of the superb products of his age, including the vast quantities of silver furniture in his own palace at Versailles. This and the subsequent history of France, culminating in the Revolution, resulted in the loss of most goldsmiths' work of the seventeenth and eighteenth centuries from that incomparable artistic centre.

In eighteenth-century Britain the foundations of modern banking were only gradually being laid and silver still retained the central rôle it shared with land as investment. The massive silver objects of the period literally represented a family's capital. After the rise in prosperity following the Restoration of Charles II in 1660 there was widespread melting down of coins and coin clippings (off the edge of coins) for investment in new plate, causing economic problems and government anxiety. In 1697 new legislation attempted to address the issue.

Since 1238 the sterling standard, named after the coins of the time, has been a legal requirement for silver in England, meaning that the alloy, necessary to harden the metal, must contain 92.5% pure silver. From 1300 the guild, the future Goldsmiths' Company, 'assayed' or tested the silver and marked it, as it continues to do today, with the leopard's head. In 1363 the maker's mark was introduced as further protection against fraud, and in 1478 the year mark, a letter of the alphabet changing each year on the feast of St Dunstan, patron of goldsmiths. May 19 is therefore the first day of the silver year, explaining the two-year date span customarily given to silver (denoting the assay date, not necessarily the date of manufacture). In 1544 the lion passant was added and these four marks have remained the London assay marks, the only changes being the addition of the monarch's head from 1784 to 1890 to prove payment of duty, and the introduction of a higher standard in 1697.

In that year a new act, designed to protect coins and to inhibit the demand for plate, enforced a standard of 95.8% pure for plate, while retaining 92.5% for coinage. New hallmarks required the figure of Britannia, which gave the standard its name, instead of the leopard's head, and the lion's head 'erased' instead of the lion passant. The maker's mark was to consist of the first two letters of his name. The registration of these marks at Goldsmiths' Hall has greatly benefitted historians by providing identification of the craftsmen. The act failed in its aims, however, and a new act in 1719 reinstated

sterling standard for plate, while retaining the alternative Britannia standard, still legitimate today. New makers' marks for sterling silver, the initials of first and last names, were required to run concurrently with the Britannia mark. A new tax did not quench the demand for plate, leading instead to fraudulent 'duty dodging' (commonly involving insertion of hallmarks from an old piece into a new piece of silver, and sometimes punching new makers' marks over old ones). The new system, with its choice of makers' marks, led to further confusion, resolved in 1739 by a new single mark of initials to be used for both standards.

Britannia mark (from B5)

Sterling mark, lion passant
(from S3)

Lion's head erased for London,
Britannia (from B7)

Crowned leopard's head for
London, sterling (from S3)

Date mark for 1716–17 (from D4)

Date mark for 1757–58 (from S3)

S8 Hot-water urn, Louisa and George, 1772–73

Tea, coffee and chocolate: the new hot drinks

At the same time as Augustin Courtauld was establishing himself as a silversmith in the early eighteenth century, tea was becoming the fashionable drink in society. The taking of tea and the other modish hot drinks, coffee and chocolate, caused a social and economic revolution. All three had first been introduced in the mid seventeenth century, challenging traditional beer and ale drinking and the comforting warm posset. Among their benefits was a stimulus to the silversmiths' trade, which provided new vessels for them. Huguenot silversmiths especially were at the forefront in grasping this opportunity for a new repertoire of shapes and a dramatically expanding market.

The new luxuries surrounding the ritual preparations and enjoyment of these extremely expensive beverages contribute to the image of elegance this period evokes. Luxury, though heavily taxed, became a fashionable necessity and played a part in the extraordinary economic growth that enriched the aristocracy and rising middle class. The nation's wealth increased at the expense of growing poverty among the labouring classes but, by the end of the century, after tax was virtually removed, even the least fortunate could enjoy the new national drink. Consumption grew from an annual quarter million pounds of tea in 1725 to over twenty-four million by the end of the century, becoming one of Britain's most significant trades.

The story of tea, coffee and chocolate drinking in eighteenth-century England originates in the adventurous seafaring trade of the two preceding centuries, and beyond that in remote countries where these drinks were first concocted. The Portuguese discovery in 1497 of the sea route via the Cape of Good Hope opened up opportunities for vastly increased trade with the Far East. Demand for the exotic treasures shipped back – spices, silks and lacquer, porcelain and tea – encouraged competitive trade among seafaring nations and led to the establishment around 1600 of the Dutch and English East India Companies. These companies, as well as private initiative, chal-lenged the mercantile advantages held by the Portuguese and Spaniards owing to their supremacy in the New World.

Coffee, originally supplied from Yemen, was widely drunk in the Middle East. After its introduction into Turkey it reached Europe through Constantinople, present-day Istanbul, where the English had set up the Turkey Company in 1581. During the eighteenth century the coffee shrub, *Coffea arabica*, was transplanted by European trading countries to many parts of the world.

The earliest known London coffee-house opened in 1652; by 1675, when there was an attempt to suppress them, there were several hundred. Modelled on Turkish coffee-houses, these new, exclusively male but socially mixed meeting places were valued for pleasure, commerce, debate and politics. As their social uses evolved some coffee-houses became gentlemen's clubs, while others specialized in business, the most famous being Lloyd's, later the world's leading insurance underwriters. Old Slaughter's (or The Coffee House on the Pavement) in St Martin's Lane was the most popular with artists and craftsmen.

The first English coffee pots had straight, tapering sides and conical covers; crude tin pots were transformed into refined silver versions, the earliest known dating from 1681–82. The drink soon spread to the wealthier houses and a lady could enjoy it in the privacy of her bedchamber. On social occasions, as with tea, the coffee might be prepared and even ground in front of guests. The standardized form of Augustin's coffee pots (A9–A14) is descended from the early Turkish-style form, but with a domed instead of a conical cover. With Samuel the form becomes more curvaceous (S2–S5). It is taller than the teapot, the spout having to rise clear of settled coffee grounds. Samuel's short-spouted jug (S6) may be for hot water or for the thick Turkish coffee, with its heavy sediment, briefly in vogue in mid century.

Chocolate, from Central America, is the oldest non-alcoholic drink, probably pre-

S11, A18 Tea kettle with stand, tea canisters and sugar box, Samuel, 1748–51

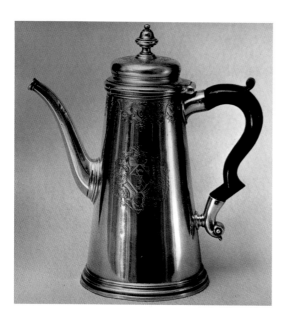

A13 Coffee pot, Augustin, 1732–33

Mayan and originating some three thousand years ago. Columbus and his crew were the first Europeans to find the cacao tree and its beans, *Theobroma* (food of the gods) *cacao*, ensuring that the sacred drink central to Mayan and Aztec culture became a Spanish trade monopoly. Spaniards sweetened the bitter brew to suit taste in Europe, where in several other countries it became the favourite fashionable hot beverage. Reaching England by the 1650s, it could be drunk in the new coffee-houses and, like coffee, was soon bought for richer households, becoming especially fashionable during the first two decades of the eighteenth century. More expensive than coffee and far more difficult to prepare, its popularity declined as the century progressed.

Chocolate could be drunk on almost any occasion. The extravagant beverage was promoted as medicinal and nutritious, accredited with almost every health-promoting virtue. The substance was sold in 'cakes' to be grated and prepared with a choice of recipes, boiled with red wine, thickened with egg, taken with milk and sugar, and with flavourings of vanilla, orange-water, almonds and spices. Specially

decorative cups, often silver-mounted, were designed for the enjoyment of this luxury, forming part of the toilet service in the bedchamber; covers retained the desired scalding temperature. It was believed to be beneficial to take all three beverages as hot as possible.

Chocolate pots, first known from the 1680s, differed from coffee pots in having an aperture in the lid permitting insertion of the swizzle-stick or 'molinet' to stir the thick sediment at the bottom. Vigorous whisking was required until the process for removing cocoa fat was discovered in the 1820s. Augustin's chocolate pot (A8) is a relatively rare object, as little silver designed for serving this drink survives. The centre of its lid pivots on a pin, disclosing the aperture for the swizzlestick, now long gone.

Tea came from China, where the legendary plant was first used to produce a brew some thousand years or more before reaching Britain. In 1610 the earliest recorded shipment brought tea to Europe. While the Portuguese were the first importers, Holland soon led the way and the fashion for tea-drinking spread from there through Europe, nowhere with greater success than in England, where it became the preferred hot drink of the eighteenth century. This may well be due to the English East India Company's own trading post established at Canton in 1699, which, unlike other agencies, ensured that the tea was carefully selected and packed to survive the voyage in good condition, producing a finer drink.

This developing custom was encouraged by the Restoration of Charles II in 1660; his return to England brought not only French sophistication but a Portuguese bride, Catherine of Braganza, whose taste for tea encouraged its adoption at court. Following the departure in 1688 of Charles's brother, King James II, the arrival from Holland of William and Mary brought support for the fashion through Queen Mary's passion for Oriental porcelain. Porcelain, regularly shipped in vast quantities with tea from the East, provided equipment for the tea table as well as ornaments for

fashionable interiors in the style of the Huguenot designer Daniel Marot.

Costly silver and porcelain formed fitting receptacles for what was a staggeringly expensive beverage. In 1660, when Samuel Pepys enjoyed his first cup of tea, the best cost £3.10s. (£3.50) a pound, equivalent to a maid's annual wages; from 1698 it was taxed by weight at five shillings (25p) a pound, and heavy duty was to lead to large-scale smuggling, encouraged by even the most respectable citizens. By 1760 tea cost only 10 shillings (50p) a pound, still forty times the price of a pound of meat.

Initially drunk mainly in coffee houses, tea was also soon bought for enjoyment at home. Promoted for its health-giving properties, it was blamed by traditionalists for numerous moral and physical ailments. As tea-drinking, with its silver and Chinese porcelain accessories and its enormous expense, became established in the drawing-room, it enhanced the position of the mistress of the house who prepared it there. In this she followed the Dutch custom. Not until later in the eighteenth century did French society adopt this ceremony à l'anglaise. The tea itself and its equipment joined the elaborate silver toilet service, first made fashionable in seventeenth-century bedchambers, in conferring status as a lady's proud possessions. Hitherto she had little to call her own; now she presided over some of the ornaments of her family's wealth, pride and position. The feminine influence brought a new refinement to social customs and an emphasis on intimacy and elegance that came to define the genteel world at this period.

The domestic group portrait, or conversation piece, which became popular in the 1730s and 1740s commonly presents the family enjoying this ritual, delicately holding their handleless porcelain tea bowls. Silver tea bowls were briefly used but soon abandoned in favour of Chinese porcelain. By the 1730s the first European porcelain from Meissen became available, qualifying as an alternative through its novelty, rarity and expense. Only after the

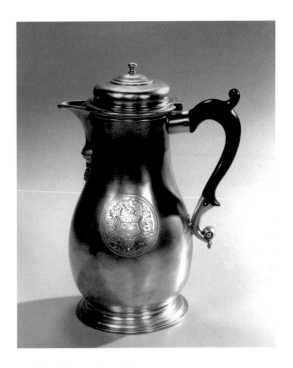

A8 Chocolate pot, Augustin, 1723–24

mid century, by which time the price of tea had dropped dramatically, was English soft-paste porcelain, followed by creamware, a serious challenge to silver tea equipment.

In a conversation piece the family sits beside a table spread with the necessary silver accoutrements. To impress the visitor these pieces should be wrought in the latest fashion, thus presenting constant opportunities to silversmiths. At first no need was felt for matching items, and Chinese stoneware mingled with porcelain and the latest English silver. The mixed service, acquired piecemeal, may sit on a large salver or tray (B14, B13). Sets of teaspoons first appeared late in the previous century (A18); they were provided with their own small spoon-tray, its form probably borrowed from items on the dressing table. There was no precedent in England for tea drinking and its ceremonies and none for the objects required: the tea service developed through experiment and innovation.

The teapot is small because of the cost of tea leaves, or perhaps also because the Chinese

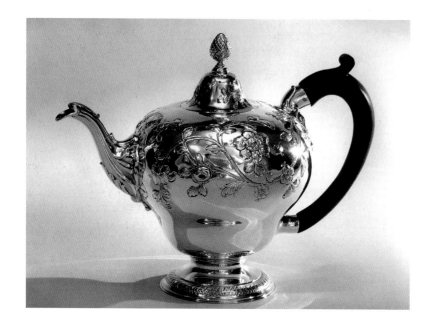

brewed tea in small pots, believing its flavour to be lost in large ones. Its varied early silver forms derived from coffee pots or Chinese tea or wine pots. The earliest to survive dates from 1670–71. As trade with China became established, instructions and models were sent to the potters there, and return shipments were laden with ceramics adapted to European requirements, such as coffee cups with handles.

When tea became cheaper the pot increased in size, as Louisa's teapots demonstrate (S12, S13). The tea kettle (S11), a standard item from about 1710, was needed for frequent refilling of the pot. Its three-legged stand fitted with a lamp fuelled by spirits of wine was developed in the 1720s; some also came with their own silver salver. For safety, the tea kettle often stood apart on a silver tripod; it was heavy and evidently lifted by a servant. After about 1760 it was replaced by the hot-water urn (S7, S8), its form descended from the wine fountain or from classical vases. It required no lifting and was more accommodating to the new Neoclassical forms. Heat was diffused from below through a metal dome protruding into the main body of each of Louisa's urns, or alternatively by the insertion of a heated iron rod.

Sugar, like tea, was at first a luxury but became increasingly affordable. From the 1640s it was imported from new British sugar cane plantations in the West Indies. Although expensive and heavily taxed it was consumed in large quantities; refined on arrival to various grades from brown to white, it was bought in the form of loaves to be broken into lumps. The sugar box was covered (A15); it may have stood alone or have matched a pair of tea canisters, stored with them in a locked tea chest (A18, S14).

The first tea containers were perhaps silver jars borrowed from the toilet service in the bedchamber; certainly the forms of early canisters from the turn of the century, as well as sugar boxes, seem to have found their inspiration there. From about 1720 canisters usually came in pairs, offering a choice of black or green tea; the earlier single ones (A17) may have been for green tea, the first to be drunk in Britain. Small caps on canisters such as Samuel's sets (A18, S14) were used to measure out the leaves. Black tea, processed through fermentation, was cheaper and became more popular, usually drunk with milk and sugar. Its best-known grades were Pekoe and Souchong and the partly fermented Bohea, often con-

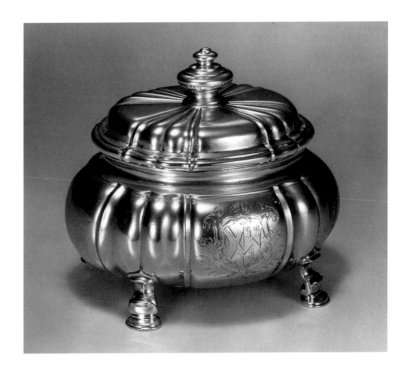

A15 Sugar box, Augustin,
1737–38

sidered synonymous with black tea. Green tea, unfermented, was graded from the finest Gunpowder to the poorer Twankay and was generally drunk without milk, as in China.

Tea remained until at least 1800 in a locked container, which by then was called a caddy (from *kati*, the Malay measurement of weight, roughly a pound). Not until the nineteenth century were the mysteries of black and green tea known to Europeans. Traders had not been allowed into the Chinese interior and the secrets of tea production, like those of porcelain, were long preserved. The Linnaean classifications, *Thea bohea* for black tea and *Thea viridis* for green, were based on a misunderstanding; rather than two different plants, green tea and black tea were the result of two different processes using leaves from the same plant, now *Camellia sinensis*.

The new hot drinks required new social ceremonies. At first tea was drunk chiefly in the late afternoon, after ladies retired from the dining to the drawing room, to be joined later by the gentlemen. In the morning ladies might drink tea, more probably coffee or chocolate,

before leaving the bedroom, and toilet services often included equipment for hot drinks for one or two persons. Breakfast, an informal meal, might be in the dining room, usually with a choice of chocolate, tea or coffee; ale still lingered on for male traditionalists, drunk perhaps from a tankard (D14), a vessel with masculine associations, but in the past a customary gift to a new mother from her husband. Tea evidently encouraged conversation and female tea parties were proverbial for promoting gossip. London's first tea shop for ladies was opened in 1717 by Thomas Twining in the Strand, and shortly afterwards the Vauxhall Pleasure Gardens were the first of many such tea gardens to open in London. Combining respectability and elegance in a public setting, they provided hitherto unknown pleasures for women.

Candlesticks and correspondence

Candlelight was the only artificial illumination for the house during the eighteenth century and candleholders of all kinds were essential domestic equipment. In a privileged household chandeliers could be suspended from the ceiling; gleaming sconces hung on the wall and torchères supported candlesticks flanking mirrors. On the dining table an épergne or centre-

B1 Pair of candlesticks, Louisa and George, 1771–72

piece (D2) might have candle branches inserted, while from the 1770s multi-branched candlesticks became more common. As the dinner hour became later, illumination in the dining room became increasingly important. The more usual single candlesticks, generally in pairs, could stand on any table or desk (A3–A5, D1, B1); all could be moved about the house. Their faceted or embossed surfaces enhanced the light shed by the flame. The modest

chamber candlestick could light your way from room to room and up the stairs to the bed-chamber (A6, A7). *No.10* is inscribed on the base of the one dated 1710–11, a reminder of the large sets households must have required.

Lighting could be enormously costly. All candles were expensive and were taxed, but beeswax candles were three times the price of tallow, animal fat which smelt unpleasant and burnt more quickly, used by the poor or for menial tasks. Tallow required more frequent trimming with the candle snuffers (A2), but even the wax candle required trimming, without which the candle would burn itself out. The self-consuming wick was not invented until the mid nineteenth century.

When not in use, snuffers were either supported in the earlier, upright stand or lay in an oblong tray, as Augustin's scissor snuffers must once have done (A2). The wick would have been snipped off by its steel blades and stored in the oval box, here inscribed *A Gift for ye Use of the Chapel*. The identity of the chapel is unknown, but the Huguenot Chapel in Orange Street, still a place of worship, has been suggested. Augustin is known to have worshipped there from 1712 to 1744 ; all his children were baptized there, and he bequeathed £10 to the chapel for the poor.

In the late seventeenth century a new type of cast candlestick gained favour. It became particularly popular with Huguenot silversmiths and its production was apparently largely the work of specialists. Cast candlesticks were expensive, using a large quantity of silver, but had the advantage of durability. All the candlesticks by Augustin are of this type (A3–A5). They were cast in three parts: base, and two halves of stem and socket. So, too, were the much later pair by Louisa and Samuel II (D1). Louisa and George's pair of Corinthian columns (B1) employ an economical device common in the latter part of the century, having wooden cores covered by sheet silver. Typically for the later period, they have separate nozzles with drip-pans to hold the

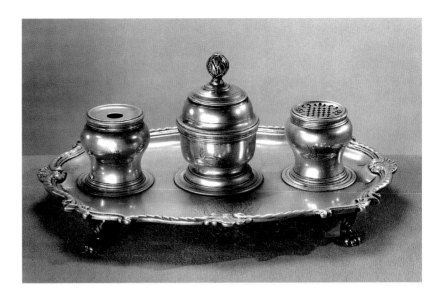

S9 Inkstand, Samuel, 1750–51

candles and catch dribbling wax; numbers, for matching purposes, indicate that they belonged to a set of at least eight.

Tapersticks, almost unknown until the early eighteenth century, are miniature candlesticks. Holding a wax taper, they were used to convey a flame to an unlit candle, or to melt wax for sealing a letter. They stood on the writing desk for that reason, rarely in pairs like Augustin's (A16), usually single, like Samuel's taperstick (S10), which is in the exceptional form of a harlequin. These harlequin designs, sometimes associated with the workshop of John and William Café, were produced over a brief mid-century period. Indeed Samuel's was evidently cast from a piece marked by another, perhaps for Café.

The form of Samuel's inkstand (S9), conventional for its time, evolved from the 'standish' first known in the early seventeenth century. On one side, as was common, is an ink pot with a hole for the quill, on the other side a pounce pot with a perforated cover. Pounce, a fine powder, was used to prepare the surface of parchment for writing. By the eighteenth century paper was in general use and the pounce pot would have contained fine sand, used to blot wet ink. In the centre of Samuel's inkstand is a wafer box for the adhesive disks

of flour and gum used for sealing letters. Other inkstands might instead have in the centre a taperstick or a bell to summon the servant.

The quill pen and ink were essential household objects until modern times, and a distinctive feature of life in eighteenth-century polite society was letter writing, an aspect of the desire for intimate communication typical of that age. For the first time, moreover, letters were regularly sent across the globe, thanks to the extraordinary expansion in world trade.

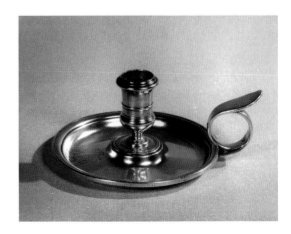

A6 Chamber candlestick, Augustin, 1710–11

Dining and display

All fashionable Europe looked towards France for the latest customs and patterns relating to behaviour or possessions. Louis XIV, who ensured that his palace at Versailles was considered the centre of the civilized world, was still living when Augustin Courtauld set up his workshop. It was the French king's intolerant policy that brought about the exodus of skilled Huguenot craftsmen to England, among other countries, contributing one more link with French culture to add to the strong ties established in 1660 by the Restoration of Charles II. While under Queen Anne court taste was sometimes prosaically English, and from 1714 George I and II introduced Hanoverian fashions, there was always a sophisticated élite who remained firmly francophile in such important matters as etiquette, refined table manners, culinary affairs and tablewares.

Age-old traditions furnished the background to newly imported customs. Throughout Europe the sideboard or buffet, with its tiers of precious vessels, had for centuries been the focus of display, confirming the owner's status, wealth and power. During meals much of the silver or gold remained there to impress guests. The ewer and basin still formed a prestigious pair, although ceremonial hand-washing had already become obsolete, especially after the use of the fork had been accepted. Massive sets of wine fountain, cistern and cooler were fashionable grand investments throughout the Restoration period and earlier eighteenth century.

Not until the early 1700s was a distinct room set aside for dining, one that remained a masculine preserve, sometimes decorated with themes celebrating Bacchus or Ceres, deities of Wine and Abundance. This set the scene for the growing fashion for entertaining guests to dinner, the time for which, while earlier in the country than in town, advanced over the years from midday to late afternoon and reached the evening only in the nineteenth century. During the course of the century the focus of display spread from the buffet, retained for the serving of drinks, to the centre of the table – a change dictated by new recipes and the new customs of *service à la française*. According to this new fashion a succession of two or more courses, each consisting of dozens of dishes, interspersed with spectacular 'remove' dishes and followed by an ornate dessert, were displayed on the table in strict symmetry, not to be disturbed until the course was removed. There was never any intention to try every dish on the table, and guests, reconciled at last to the foreign use of the fork, helped themselves or each other from dishes in front of them, or received food carved or ladled by the host or hostess. Servants were occupied with passing round bread and condiments and with serving wine from the sideboard.

The small waiter or salver (A19, D16, B12) was used everywhere in the house as an essential support for any item offered by a servant on any occasion, both as a mark of respect and to prevent spills. Glasses had no place on the dining table until around 1770, and the diner requiring a drink summoned a servant who filled a clean, sometimes chilled glass at the sideboard with wine, also served chilled from the cooler (whatever the colour), and offered it on a waiter or salver before returning it immediately to be rinsed in the cistern. These rituals explain the drinking equipment of the period and, incidentally, the vine decoration on Samuel's pair of waiters (D16), a term used nowadays to differentiate smaller salvers from larger ones, such as Augustin's square salvers – a shape introduced early in the century (B12). Sets of salvers were also used to support fruit on the table, or clustered cups of delicacies.

As with hot drinks, fresh customs dictated new and more sophisticated tableware. In the case of dining these were adopted from the French, although often they originated in Italy. No longer content with the vast array of open platters typical of the seventeenth-century feast, when the food itself provided the décor, the fashionable eighteenth-century table acquired ever more varied receptacles, often with elab-

B6 Cup and cover, Augustin,
1725–26

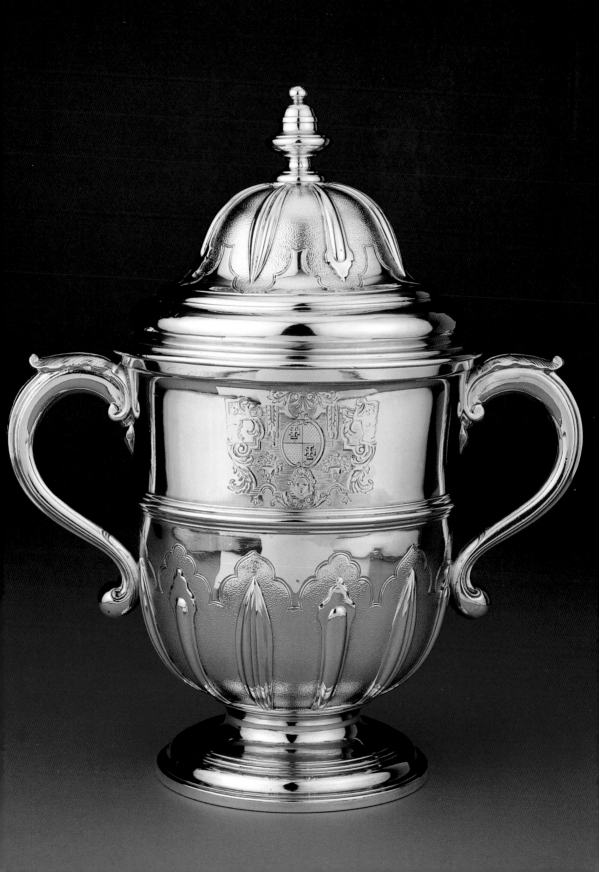

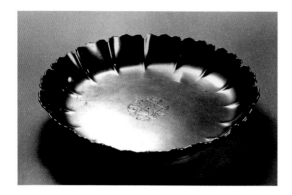

D4 Dish, Augustin, 1716–17

orate covers required by the new interest in keeping food warm. Patronage of the most expensive tableware was inevitably confined to the nobility, and those who could afford it ordered from the incomparable French goldsmiths, whose work is now largely known only through such foreign commissions.

The matching dinner service developed especially from the 1730s onwards. Most plate, however, was ordered piecemeal, invested as wealth accumulated. Up to four fifths of household silver is estimated to have been made for the dining room and, until challenged by the porcelain dinner service, this would have included, for the rich, dozens of plates of precious metal, few of which have survived the melting pot. Among these, during the period approximately 1715–45, would have been sets of dishes typically featuring fluted upcurved sides and scalloped rims (D4). Now, without reason, sometimes called strawberry dishes, in the eighteenth century they were known as 'sallet' or salad dishes, a term used to describe all vegetables, whether raw or cooked – an increasingly popular food.

Pride of place formerly belonged to the ceremonial salt; this symbolic item was replaced by the more useful but equally elaborate and extravagant centrepiece or épergne (D2).

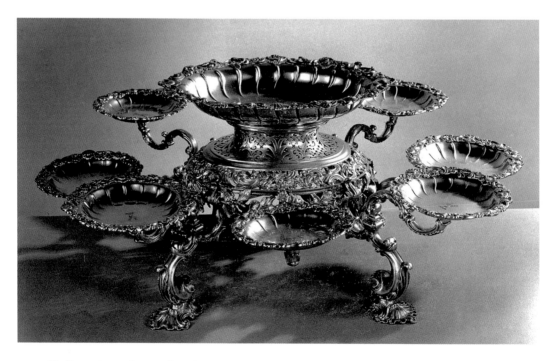

D2 Centrepiece or épergne, Samuel, 1751–52

Known in France as the *surtout*, it originated with Louis XIV's goldsmiths in the 1690s, perhaps evolving from the custom of placing a dish on top of the standing salt. The multipurpose creation at first embodied a large tureen, surrounded by casters and cruets which could be substituted by detachable candle branches and dessert dishes, and could therefore remain dominating the table throughout the meal.

Records show that these novel showpieces were emulated by English silversmiths from the second decade; they became the focus of ingenuity throughout the period reviewed here. As the century progressed, the épergne sometimes shared the centre of the table with flowers, whether real, sugar or, later, porcelain, and its construction became lighter, a gift especially to the Rococo taste for the fanciful. The épergne also accommodated the fashion for intimate occasions, especially candlelit suppers, serving as a dumb waiter when the servants were dismissed. It is not known what other components this épergne marked by Samuel I of 1751–52 (D2) possessed, but perhaps candle branches were once available. Three other centrepieces of Samuel's survive.

Next in importance and expense was the tureen (D15), another new form introduced from France, where it was known as a *soupière* or *pot-à-oille*, or later *marmite*. Developed in the 1690s originally as part of the *surtout*, the tureen accommodated the newly fashionable soups, ragouts or stews, notably the *oille* or olio of Spanish origin, a reminder that Louis XIV's queen came from Spain. The earliest surviving English tureens date from the 1720s, although they are recorded earlier, and seem at first to have been a speciality of the Huguenot silversmiths. The early ones may be round, but the oval soon became increasingly popular; they were usually disposed in pairs or two sets of pairs, dominating each end of the table during the first course. Unlike their French counterparts, few of which survive, most were supplied without stands, and their supporting feet were

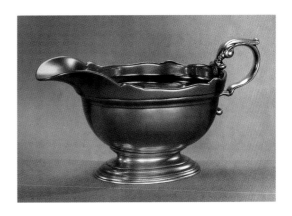

D8 Sauceboat, Augustin, 1733–34

disposed two at each side, rather than, French-style, at the centres of the long and short sides. Like the épergne, the tureen became a focus for the silversmith's virtuosity, flights of fancy sometimes including sculptures suggestive of its contents – vegetables, game or crustaceans.

Another novelty introduced principally by Huguenot silversmiths was the sauceboat (D8–D10), again a focus of fashionable interest; it formed part of the rigidly symmetrical table plan and was always produced in pairs or larger sets. French cooks created delicate sauces and to serve them there emerged in France the double-lipped, two-handled sauceboat, popular by 1700. The earliest known in England date from just before 1720; the single-lipped form with one handle was introduced a few years later, gradually becoming more bulbous (D10). Two-handled sauce tureens were popular from around 1760 (D11, B15); they would generally have been provided with stands and, having no lip, with ladles.

Other essential tableware included the salts; no longer prominent but much smaller in size, as was already the fashion in the previous century, they were made in sets to be put between or in front of each diner. Augustin's pair (D6), gilt internally for protection, evidently formed part of a larger set, and perhaps belonged with six others that are known, matching these but with crests possibly for Brudenell. This type was introduced in the 1730s and was common for most of the century, but the

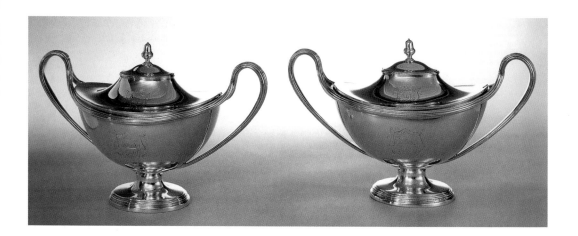

B15 Sauce tureens, Louisa and George, 1774–75

D6 Salt, Augustin, 1742–43

dolphin feet, alluding to salt's marine origin, provide unusual interest.

Casters and cruets, sometimes gathered on to the centrepiece, in time found their way off the table and on to the side board, held together in a stand or frame and offered by servants during the meal. Nowadays often surviving singly, casters commonly came, after the 1670s, in sets of three for pepper, sugar and mustard. Augustin's caster (D13) was evidently part of such a set, as was Louisa and George's remarkable condiment vase (D3) made fifty years later. On the evidence of closely related objects it would have been the largest of a set of three, intended for sugar, and have had an attachment for a ladle. Samuel's container of 1750–51 (D12) is thought to be a spice canister, possibly from a centrepiece or condiment stand. Pepper, mustard and strong spices were then essential for disguising the taste of salted, dried or rotten meat.

The bread basket (A1, S1), sometimes known as a cake or fruit basket, had a number of uses, but was principally for bread, handed round by servants during dinner. Until the Napoleonic Wars, when the high price of wheat caused the potato to be substituted as staple fare, bread had a greater importance as an accompaniment to other foods. The silver table basket at first closely imitated the humble wicker object. The initial loop handles were replaced in the early 1730s with the fixed arch handle and by 1740 with the swing handle, while the flaring shape, raised from a single sheet of silver, was adorned with Rococo inventiveness, as is Augustin's splendid basket of 1745–46 (A1). A comparable silver basket laden with fruit appears in Hogarth's near-contemporary portrait of the Graham children in their drawing room (National Gallery, London). Later in the century, baskets were elegantly decorated with more sober piercing and constructed on elevated bases, as is Louisa and George's (S1). As a centrepiece on the dessert table the basket might hold sweetmeats, fruit or flowers; used for bread, its place would

be on the sideboard. The sideboard and buffet retained their importance, although it was increasingly shared with the central dining table.

The eating rooms of Sir Robert Walpole at Houghton in the early 1730s and of Nathaniel Curzon, 1st Baron Scarsdale, at Kedleston thirty years later are landmarks of innovation during the period under review. The fashion arose early in the century, first at Houghton, for the buffet to be contained within a niche in the dining room. The contents of such a niche in the grandest houses were at first dominated by the wine fountain, cistern and cooler, of which only the Earl of Macclesfield's set survives intact (Victoria and Albert Museum, London). The ewer and basin, no longer functional, retained their position on display, and the larger salvers were also often for show rather than use. The present pristine, unscratched state of Louisa's large salver (B14) suggests just such a station on the buffet; although its size suggests a purpose as a table top, its delicate construction makes it impractical for carrying.

The incomparable prestige of the two-handled cup is indicated by the disproportionate number that survive (B2–B11). When a precious commemorative gold piece was commissioned it would inevitably take that form, like the Pelham Cup designed by William Kent. The type is perpetuated now principally as a sporting trophy, which indeed was sometimes its function from around 1650, but its present associations cloud our perception of the dignity and honour in which the object was once held. It is *par excellence* a piece for display on the buffet, although it also served on occasion as a wine cup to be passed around as a gesture of fellowship – a use still observed by livery companies in the City of London, who likewise display their silver on sideboards or buffets on ceremonial occasions. In great houses, by the latter part of the century, not only guests but also genteel tourists would be permitted to admire the accumulated wealth on the owner's buffet.

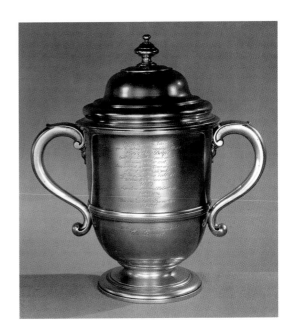

B3 Cup and cover, Augustin, 1714–15

The ceremonial cup provided the ideal vehicle for the skills and taste of Huguenot silversmiths. Its form was not French, however, but was an amalgamation of two indigenous sources, the ceremonial standing cup of medieval origin and the functional, two-handled porringer with cover popular in the seventeenth century. It became one of the classic forms of early eighteenth-century silver in Britain, as is demonstrated by the series bearing Augustin's mark (B2–B7). Particularly interesting is his cup of 1714–15 (B3), commissioned to commemorate posthumously the touching friendship between Gilbert Burnet, Bishop of Salisbury (1643–1715), and Robert Boyle (1627–1691), leading member of the Royal Society and the founder of modern chemistry. The distinction of the two latest cups, the one designed by Sir William Chambers and supplied by Louisa and George (B10) and the other, silver-gilt, in the style of Adam and marked by Louisa and Samuel II (B11), is magnificent proof of the continuation of this great tradition.

Engraving and armorials

The first few decades of the eighteenth century witnessed a flourishing of the art of engraving on silver, yet the engravers themselves are now often shadowy figures. Their anonymity does not necessarily indicate a lowly grade in the craft's hierarchy, but results from lack of records and scarcity of signed work. Although many names are known from documents they can rarely be attached to known work, a cele-

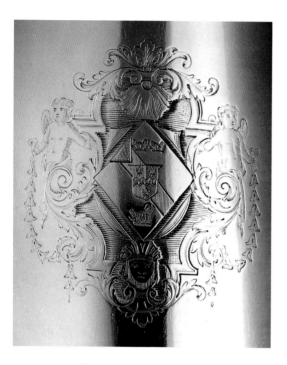

A13 Coffee pot (detail), Augustin, 1732–33

brated exception being the engraving attributed to William Hogarth on Paul de Lamerie's seal salver made for Sir Robert Walpole in 1728–29.

An earlier salver made for Walpole (now lost), also fashioned from his seal of office as Chancellor of the Exchequer, was engraved and signed by Joseph Sympson, whose career from around 1710 to 1747 coincided with Augustin's. Amongst other work attributed on stylistic

grounds to Sympson are the engraved decorations including armorials on Augustin's rectangular salver of 1724–25 (B13), his circular shaped salver of 1728–29 (D7), a ceremonial cup of 1731–32 (B7), the fine coffee pot of 1732–33 and closely similar coffee pot of the same date (A13, A14).

Two engravers named Joseph Sympson, presumably father and son, were among the early members of the St Martin's Lane Academy, a centre of crucial artistic importance, founded in 1720; their workshop was evidently soon employed by some of the most prominent silversmiths of the day. An understanding of this practice sheds light on similarities between pieces from different workshops, while suggesting caution in attributing work to individual engravers. Designs in pattern books were available to all, and reproduction was possible from paper transfers and from 'pulls' from existing engravings. Simon Gribelin, a Huguenot silver engraver of the previous generation, was famous for publishing designs at the turn of the century reproduced from his own engraved work. As so often, the inspiration derived from France, notably from the celebrated designer Jean Berain and his influential Huguenot follower Daniel Marot, who came to England with William and Mary.

The prominent display of engraved armorials on silver was a recognized expression of pride in lineage and wealth. Beauty of design and skilled execution enhance the quality of many objects here, but the armorials themselves also remain of interest by serving to identify patrons, or subsequent owners where the armorials are later additions. While many of Augustin's customers belonged to the modest gentry, the distinction or nobility of certain of his patrons is confirmed by pieces here. The cup of 1714–15 (B3) commemorates the eminent scientist Robert Boyle. Another cup of 1723–24 (B4) carries the arms of Francis, 2nd Earl Godolphin (1678–1766), later Lord Privy Seal; he married Henrietta, eldest daughter of the great Duke of Marlborough and from 1722

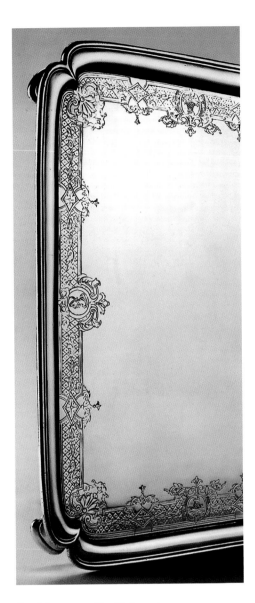

B13 Salver or tray (detail), Augustin, 1724–25

Duchess of Marlborough in her own right. The rectangular salver of 1724–5 (B13) belonged to John, 3rd Baron Ashburnham (1687–1737), created Earl in 1730. A different social class is associated with the coffee pot (A14) carrying the arms of alderman Sir Thomas Hankey, whose father-in-law became Lord Mayor of London in 1738; Augustin's sugar box (A15) carries those of Sir Caesar Hawkins, Sergeant-Surgeon to George II and George III.

At the end of this period, the arms on Louisa and Samuel II's silver-gilt cup (B11) identify the owner as John FitzGibbon (1748–1802), created Earl of Clare in 1795, whose intolerant policies as Lord Chancellor of Ireland profoundly influenced that country's history. The cup is dated to the year he entered the Irish House of Commons. Nothing as yet is known about the fine engravers of two other late pieces, Louisa's large salver (B14) and Louisa and George's condiment vase (D3), the latter ornamented with a continuous scene of warriors in a landscape, evidently from the same workshop as the similarly engraved set made for Kedleston (see further pp. 38-39).

Armorials are governed by complex rules and described with obscure terminology reflecting their medieval origin. They consist of a coat of arms, inherited or granted, with charges (bearings or devices) displayed on an escutcheon, often shield-shaped, which, for the aristocracy, may have supporters (figures or animals) at each side, a motto beneath, a helmet displaying a crest above, and mantling (flowing drapery) surrounding the helmet and representing its protective cloth or surrounding all these items and representing a robe of honour. The whole may be set within a decorative cartouche (frame derived from parchment scrolls). Tinctures (colours and metals) are represented by a system of lines and dots invented in the seventeenth century. The crest, sometimes common to several families but requiring less space and cost, is often engraved alone; cyphers or monograms may also be used.

Early Huguenot silver and the 'Queen Anne' style

The years covered by the Courtauld silver-smiths' activity can conveniently be divided into three stylistic periods, coinciding more or less with the three generations. The earliest, most typically associated with the Huguenots, is represented by Augustin. The period is popularly associated with a plain, well-proportioned style in architecture and the decorative arts known as 'Queen Anne,' a style which with time came to merge with the

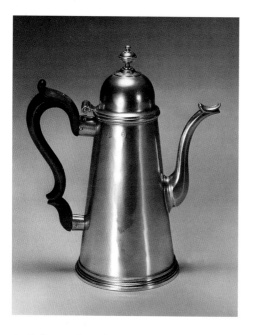

A9 Coffee pot, Augustin, 1713–14

features of Huguenot craftsmanship. The sobriety represented by this period was challenged by the fanciful Rococo, an extraordinary fashion first surfacing in this country in silver-smiths' work of the 1730s, and ably followed by Samuel. There followed in the 1760s the re-straining influence of Neoclassicism, the veneration of Greek and Roman antiquity that by the end of the century reigned unchallenged in the arts. Louisa and her partners responded notably to these demands.

Augustin's earliest works (A6, A7, A9, B2) have the simple, enduring appeal typical of their time. He long continued to practise in the style of his youth, evidently acquiring a contented clientèle who eschewed the excesses of Rococo. There were many such patrons in England. One of the richest was George Booth, 2nd Earl of Warrington. His extravagant holdings of fine-quality plate, much of which survives at Dunham Massey, were ordered as his wealth accrued, almost all from Huguenot silversmiths, and barely changed in style over half a century. Cost was governed by two factors, the weight of the metal used – often originating in the patron's own outmoded silverware – and the elaboration of the decorative design. A piece of plain silver could be melted down and re-used virtually without loss. 'Fashioning' and engraving were separately itemized, and a highly wrought or decorated piece was a conspicuous extravagance that could not be justified as an investment, but only by a desire to be abreast of the latest designs. The Rococo style, in any case, was received with only limited acclaim and a sensible man might well prefer to invest his wealth in larger quantities of plainer plate.

Augustin evidently provided for a certain type of client, producing a succession of dignified objects in high-quality Britannia silver long after many silversmiths had returned to the sterling standard (see pp. 10–11) and taken to new fashions. He did not register his sterling mark until 1729, ten years after he could have adopted this more economical standard, and he continued to produce Britannia silverware until at least 1730 (A12, B7).

The 'Queen Anne' style is associated with the taste prevailing from the 1690s to the 1720s and therefore also covers the reigns on each side, William and Mary and George I. In silver it represents the continuation of the plain wares which appear to have been in demand throughout the seventeenth century, coexisting latterly with the embossed, floral style of Holland. Often misleadingly associated with Puritanism,

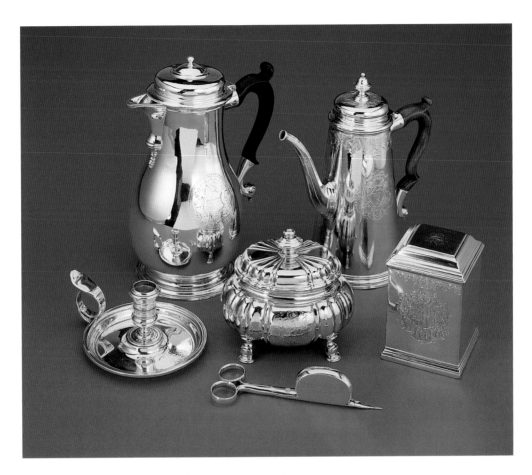

A2, A6, A8, A13, A15, A17 Household silver, Augustin, 1710–38

these modest pieces may simply represent a standard type that has not survived from earlier years. The eighteenth century, with no religious upheaval or civil war, was the first in which large quantities of silver escaped melting down. Silver was in greater supply; but the enduring appeal of the perfected plain style, to which Huguenot craftsmen notably contributed, may also have ensured their preservation.

The style with which Augustin appears largely to have been identified is characterized by this timeless appeal of simplicity, allied with fine workmanship. Native silversmiths had habitually used a thinner gauge of metal, ap-

propriate to the embossed decoration and flat-chasing of the previous century. Reactionary and defensive, few of these smiths could at first challenge the skills of the 'aliens', whom they tried to exclude from the craft. Eventually they came to emulate the newly introduced traditions and skills. The émigrés knew, if only from prints, of the latest Paris fashions, and they favoured decorative additions requiring a quantity of higher-gauge metal and skill in execution. Typically they used cast features and cut-card work (see p. 8), which could be elaborated to create strapwork – elongated leaf-like strap motifs cut from sheet silver and attached with solder, as on Augustin's two-handled cups (B5–B7).

These prestigious cups are an English, not French form, but are classic representatives of Augustin's work and of Huguenot silver in general during the first decades of the century. They are characteristically weighty, dignified, beautifully proportioned and skilfully crafted in Britannia standard silver. An examination of Augustin's six cups in the collection illustrates some of the changes of the period and its increasingly rich decoration. The first (B2), of 1713–14, is a fine early example of the type. Probably designed without a cover, it has the simple S-shaped handles already used in a lighter form by native smiths, but cast more solidly by their rivals; the bands or girdles formed by drawn wires soldered round the body are a typical Huguenot touch that enhances the cartouche. In the following year Augustin produced his important Boyle commemorative cup (B3), on which the dignified inscription, underlined by the drawn-wire band, provides the ornament. The domed cover is an important Huguenot innovation – replacing the virtually flat covers of the previous century. The Godolphin cup (B4) is taller, slightly increasing the height vis-à-vis the width across the handles, which previously was almost equal. The Ward cup of the same year (B5) is more ornate, the first here to be decorated with the typical Huguenot motif of cut-card strapwork. The Crosse cup (B6) is finely detailed, distinguished by the 'matted' ground (see p. 8) enhancing the strapwork, while the Clarell cup (B7), has for the first time double-scroll handles, introducing a lighter touch typical for its date in the early 1730s.

The importance of engraved decoration, usually limited to armorials or flat border designs (see pp. 26–27), is exemplified by Augustin's large salvers, one in a rarely seen rectangular shape (B13) with incurved corners, a feature first seen around 1720; the other circular in form (D7) with the typical shaped border sometimes known as a Bath rim.

At this period innovation was essential, in order to meet the demands made by new eating

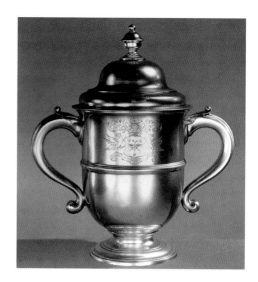

B4 Cup and cover, Augustin, 1723–24

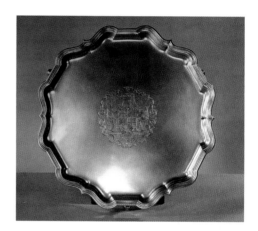

D7 Salver, Augustin, 1728–29

and drinking habits. Judging from surviving objects, Augustin appears to have produced large quantities of equipment for the fashionable hot drinks. This collection of coffee and chocolate pots again provides a survey. The six coffee pots are standardized and straight-sided – the tapered, cylindrical, typically English form, common since the earliest known example of 1681–82 and deriving apparently from the Turkish shape. The original straight-sided conical cover has given way to the high dome seen in the two earliest here (A9, A10); this in

turn is succeeded by the flattened covers of the four later coffee pots (A11–A14). All spouts are octagonal, whether straight or curved – thus markedly different from French spouts, which were attached at right angles (a feature also seen in some earlier English pots) – while the wooden handles are scrolled or double-scrolled. The two latest coffee pots (A13, A14) are contemporary and very similarly engraved, but the 'Wall of Preston' pot (A13), distinguished by its excellent state of preservation, is of exceptional perfection. The finely proportioned chocolate pot (A8) is pear-shaped, a form almost universal for coffee pots in France and other Continental countries.

Many tea-wares by Augustin survive, but only two in this collection. The tea canister of 1725 (A17) has a geometrical shape no longer the height of fashion, but its status is enhanced by a fine engraved cartouche, and it is worth noting that the extravagant but conservative 2nd Earl of Warrington ordered a pair of similar form as late as 1754–55. The sugar box of 1737–38 (A15) is one of Augustin's latest pieces in the collection; it appears to have belonged to a set, since two taller tea canisters by Augustin in this pleasing form are known.

For the dining table there is a fine dish of 1716–17 (D4), perhaps one of a set – an example of a distinctive fluted design, occasionally elaborately chased and engraved, that was introduced around 1710 and highly popular by 1720; the appeal of its scalloped fluted edge is enhanced by the solidity of the Britannia silver. The caster of 1721–22 (D13) is of baluster-vase shape with applied strapwork typical for its date; it must once have belonged to a set of three, and was perhaps originally flanked by a surviving pair marked by Augustin not in the collection, which are similar but smaller, and of the same year. As noted above (p. 23), the two salts of 1742–43 (D6) may likewise have formed part of a larger set of which six others are known; they are distinguished by their dolphin feet, a marine allusion common in the Rococo style. Many sauce boats of Augustin's

D13 Sugar caster, Augustin, 1721–22

survive, including some of the early double-lipped form. The pair in the collection of 1733–34 (D8) belong to the early single-lipped type standing on an oval foot.

There is such consistency among these pieces that the elaborate Rococo basket (A1) marked for Augustin towards the end of his life, as well as his grand centrepiece at the Hermitage in St Petersburg, are often considered to have been Samuel's responsibility after his father had retired and his 'house style' been abandoned.

Silver and the Rococo style

'Rococo' is a nineteenth-century term of ridicule to which at different times various meanings have been attached. The elusive definition has now lost its derogatory overtones and is applied to aspects of eighteenth-century taste and style in a variety of ways, either broadly including the liveliness, intimacy and impatience towards rules seen in all the arts, including literature and music, or more narrowly marking a certain type of ornament used principally in the decorative arts. In the latter sense the phenomenon was known in France, where it originated, as the *genre pittoresque*; in England it was 'modern', 'modern French', 'contraste' or '*pittoresque*'. However interpreted, the Rococo represents a light-hearted attitude to life and art which was either embraced with enthusiasm or rejected with derision.

Its sources have been traced to sixteenth-century 'grotesque' designs deriving from the antique, to aspects of the Italian Baroque and to the work of artists including Stefano della Bella in the seventeenth century, as well as to the Dutch 'auricular' style, while its immediate origins are located in the *style régence*, that lightening of French taste in the first two decades of the eighteenth century, embodied for many in the art of Antoine Watteau, who briefly visited England in 1719–20.

The decorative motifs of the Rococo, essentially curvaceous and asymmetrical, include *rocaille* (the rocky substance used for artificial caves), water, shells, crustaceans, dolphins and other phenomena with marine associations, including tritons and nereids; a particular kind of twisting cut leaf known as the raffle-leaf; naturalistic plants, animals, insects and reptiles; fantastic creatures, *singeries* (monkeys 'aping' humans), precocious infants indulging in adult occupations, harlequins and other figures from the *commedia dell'arte*; a frequent use of scrolls and masks and of the cartouche, not only for inscriptions or armorials; wild foliage and caves as settings for figures of disproportionate scale, architectural settings denying any sense of structure, a defiance of gravity and rules and a swirling three-dimensional plasticity. The Rococo also adopted *chinoiserie*, that *pot-pourri* of the exotic Orient first introduced in the previous century, which was especially appropriate for tea equipment, while narrative was abandoned in favour of amorous scenes.

Even during the eighteenth century it was recognized that Juste-Aurèle Meissonnier, French goldsmith and architect who came to Paris from Turin, was responsible for the introduction of the *genre pittoresque*, its first manifestation, in 1728, being an extraordinary candlestick. This featured among prints of his designs published in the 1730s, part of that mass of etchings and engravings which epitomized the style as well as spread its influence abroad. In some regions it took on an enduring life of its own, notably in Central European architecture; indeed, the *genre pittoresque* in France remained more controlled than the exuberant excesses which it manifested elsewhere, including Britain.

The Rococo first reached England from France during the 1730s, in the form of silverware and through the medium of prints. The Duke of Kingston could afford to commission silver from Meissonnier himself, notably an extraordinary centrepiece and tureens, and a few other rich noblemen acquired work from Paris goldsmiths such as the great Thomas Germain or Jacques Roettiers. In England it was above all Paul de Lamerie who, from the 1730s, produced the most sensational work of this kind; he was followed with distinction by Paul Crespin and Nicholas Sprimont. Huguenot craftsmen retained strong links with France and were open to influences from Germany; they continued to dominate silver production throughout the Rococo period, rising to meet the challenge of the new and increasingly popular European porcelain and creamware.

The wealth of opportunities for artists and craftsmen in England continued to attract large numbers of foreigners, whose contributions to the artistic scene were crucial to its develop-

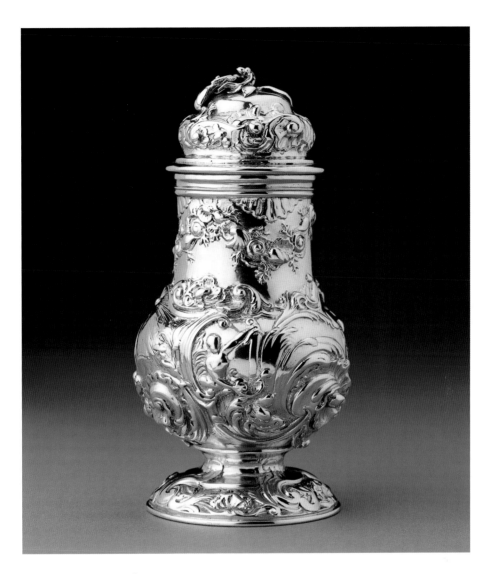

D12 Spice canister, Samuel, 1750–51

ment. The Academy in St Martin's Lane, with tutors such as Moser, Gravelot and Roubiliac, was a central point of diffusion. During the 1740s the new style, previously confined largely to goldsmiths' work, became more widespread, and transformed fashionable furniture and furnishings, even invading the garden. The championship of the 'serpentine line' in his *Analysis* *of Beauty* of 1753 by William Hogarth, founder of the new St Martin's Lane Academy, supported the fashion just when its detractors were becoming more widely heard.

For the goldsmith, the new style was crucially dependent on skilled modellers and chasers (most of whom remain nameless), and to a lesser degree than before on engravers. It

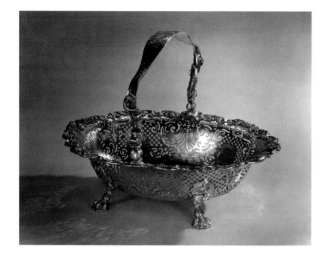

meant a merging of ornament and form, a sense of movement replacing one of repose. This was the stage on which Samuel Courtauld played an enthusiastic rôle, not as a star actor but prominent in the cast, his work echoing that of Paul de Lamerie and perhaps even sharing some of his moulds, models or craftsmen.

The earliest piece here to display the new features is the basket marked by Augustin for 1745–46 (A1); for that reason it is usually attributed to his son Samuel's supervision, but it may be the work of John Jacob (see p. 9). Its ornament includes many of the motifs listed above, the scrolls, *rocaille*, and fish-scales surrounding a *rocaille* and floral cartouche containing armorials at the bottom of the basket; the naturalistic vine with grapes and satyrs' masks, applied above pierced designs to the well-turned back border; the shell and claw feet, and the dolphin supports for the swing handle, itself an innovation of the 1740s. Three years later, while Augustin was still living, Samuel produced under his own mark a kettle, stand and lamp (S11) exhibiting another set of motifs, naturalistic flowers and leaves mingling with *rocaille* and scrolls to cover the inverted pear-shaped body – a recent innovation – topped by a pineapple finial, the stand festooned with flowers and resting delicately on *rocaille* feet.

The four coffee pots (S2–S5) and a Turkish coffee (or hot-water) jug (S6) date from 1750 to 1762; all the coffee pots have scroll spouts with foliate scrolls at the base and a leaf at the end, while their baluster forms become increasingly attenuated. The jug and the second coffee pot, dating from the late 1750s, are ornately embossed with scrolls, *rocaille* and floral swags. The latest two, a couple of years on, depend for decoration principally on gadrooned mouldings, a French fashion newly introduced; other surviving, very similar, coffee pots by Samuel, who appears to have specialized in these items, attest to their popularity.

Also belonging with the hot drinks equipment are the tea canisters and sugar boxes in their chests (A18, S14), the earlier covered in shagreen, a fine durable leather made from shark or sting-ray skin, commonly dyed green, originating in the East and recently taken up by leather-workers in Paris. The two sets date from 1750–51 and 1764–65, the first representing the height of the Rococo style and the second its later phase, the unfettered *rocaille*, the flowers and scrolls of one giving way to formal spirals and swags on the other. Samuel's sauceboats (D9, D10) also date from 1750–51 and 1764–65, the earlier pair having above each *rocaille* foot the mask of a turbanned infant, enhanced by further *rocaille*, instead of the lion's mask popular since the 1730s. The harlequin taperstick (S10) takes up another favourite

Rococo theme, from the *commedia dell'arte*.

The grandest pieces are Samuel's épergne and tureen, both dated for 1751–52. The splendid centrepiece (D2) is decorated on a grand scale with pierced and cast work; later developments with piercing were to produce increasingly airy effects, culminating in the 1760s with extravagant Chinese pagoda forms. The tureen (D15) is his undoubted masterpiece in the collection, adorned with superb applied cast features – the scrolling cartouches on each side and the looping leaf-capped handles, each embellished with *rocaille*, flowers and foliage; the floral finial; the *rocaille* feet beneath scrolls topped by goats' masks instead of the more usual paw feet and lions' masks. The scrolling legs and goats' masks correspond to those on Paul de Lamerie's tureen for Baron Anson of the previous year, and the floral finial is a version of a form found on other tureens by de Lamerie. The flower forming the finial may be identified as *Anemone coronaria*, cultivated during the eighteenth century in many fashionable and expensive varieties; the same flower appears among the embossed ornament. The features in common with de Lamerie's suggest the sharing of craftsmen, exchange of moulds or purchase of ready-made ornaments.

The spice canister of 1750–51 (D12) epitomizes within its modest dimensions the Rococo repertoire, with its *rocaille*, splashing waves and swags of shells, coral and seaweed framing a nereid, a heron, a fish, a bird and a sun in splendour, conceivably alluding to Samuel's maker's mark or to the sign above the Courtaulds' shop in Chandos Street.

Samuel's widow Louisa continued to produce silverware in the evolved Rococo style. From the year of Samuel's death there are two large two-handled cups of traditional form but far more ornate than any others in the collection, with a pear-shaped body, elaborate double-scroll leaf-covered handles and tall covers. One (B8) has spiralling scrolls and forms reminiscent of auricular shapes; the other (B9), with embossed cartouches, is cov-

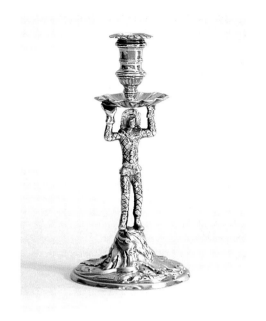

S10 Harlequin taperstick, Samuel, 1755–56

ered with grape-laden vines. An inverted pear-shaped teapot of the same year (S12) is charmingly embossed with the leaves and flowers of the tea plant. From 1767–68 there is a hot-water urn (S7) chased with even more pronounced auricular forms, and an enormous salver (B14) with ornate cast pierced border and, on its impeccably preserved surface, engraved armorials with ribbons, swags and sprays of flowers.

Working with her partners Louisa produced fine Neoclassical work, but also, with George, objects which illustrate a compromise between the Rococo and the 'antique manner'. From 1768–69 there is a set of four covered sauce tureens (D11), with gadrooning, scrolls, shells and pomegranate finials; followed by a basket marked 1771–72 (S1) which presents an illuminating contrast with that of 1745–46 (A1): the pierced decoration is without movement, the cast border and handle less bold, the foot a continuous oval support. With Samuel II, in 1778–79, Louisa marked a pair of surprisingly old-fashioned candlesticks (D1), with spiralling scrolls still reminiscent of auricular forms.

Silver and the Neoclassical style

Neoclassicism was a movement inspired by architects, arising in the mid eighteenth century in the British Isles and in France and flourishing in all the visual arts for over half a century. Its principal protagonists in this country were Robert Adam, James Stuart and Sir William Chambers, who all had studied in Rome around 1750. They helped to bring about a revolution in taste, inspired by a fresh look at the art and architecture of the ancient world and breathing new life into the continuing Palladian tradition in Britain.

The swing in fashionable taste to the 'antique manner', as it was then known, was an inevitable reaction to the levity of the Rococo and a desire for a return to rational order and discipline. It involved a seriousness of outlook and search for authority, inspiring a new antiquarianism which found special impetus in the archaeological discoveries at Herculaneum and Pompeii taking place during the 1740s and 1750s. By the 1760s these sites could be inspected by visitors on the Grand Tour and by the 1780s these tours were no longer the preserve of the classically educated privileged classes. The taste for the 'antique manner' at the same time lost its exclusivity and appealed to a wider public.

For the first time, too, the art and architecture of ancient Greece was studied and emulated, giving a nickname to James 'Athenian' Stuart. He, Adam and Chambers exerted their influence as architects through an interest in design embracing every aspect of furnishing, an innovation with which the Scottish architect is often credited but which in fact originated with Daniel Marot, Huguenot architect and designer to William and Mary. Adam was largely responsible for the interiors of Home House in London, where the Courtauld Institute of Art was housed for nearly sixty years, while his great rival Chambers, architect to George III, designed Somerset House, its present home. Each included silver among his designs.

One principal element in Neoclassical decorative design is the vase, whether reproduced in one of its antique forms, applied as a two-dimensional motif, or employed to lend its shape, however inappropriately, to all kinds of domestic objects. A variety of sources for vase designs was found, from Renaissance prints to recently discovered examples. Another favourite was the classical tripod altar; the oval, meanwhile, relating to antique gems and cameos, became a ubiquitous shape. Ornament, essentially applied symmetrically, was generally confined to motifs with antique provenances, such as acanthus, swags, medallions, husks, palmettes, the grotesque, sacrificial utensils and animal masks of the kind found on antique reliefs, and the elements and orders of classical architecture.

Publications associated with this antiquarian movement became immensely important during the period. Chambers published *A Treatise on Civil Architecture* in 1759; Stuart, with Nicholas Revett, published *The Antiquities of Athens* in 1762, the first volume of its kind; in 1764 Robert Adam published drawings of ancient ruins in Dalmatia, and with his brother James published their own architectural work from 1773 onwards. Baron d'Hancarville published his *Collection of Etruscan, Greek, and Roman Antiquities*, from Sir William Hamilton's collection, in 1766–67. The latter volumes were specifically intended to provide models for artists and designers, and were immediately taken up by Josiah Wedgwood, who, catering for what he termed "vasemania", produced a sequence of basalt, terracotta and jasper vases, many of them based on those in Hamilton's collection, which in 1772 was sold to the British Museum. With Matthew Boulton, Wedgwood was the most significant manufacturer to popularize this taste, and both manufactured work designed by Chambers.

During their last decade, the Courtauld workshop produced several outstanding pieces of Neoclassical silver, first marked by Louisa with George, then by her with her son Samuel II, a partnership from which few pieces are known. With George, Louisa marked in

B10 Cup and cover designed by William Chambers, Louisa and George, 1770–71

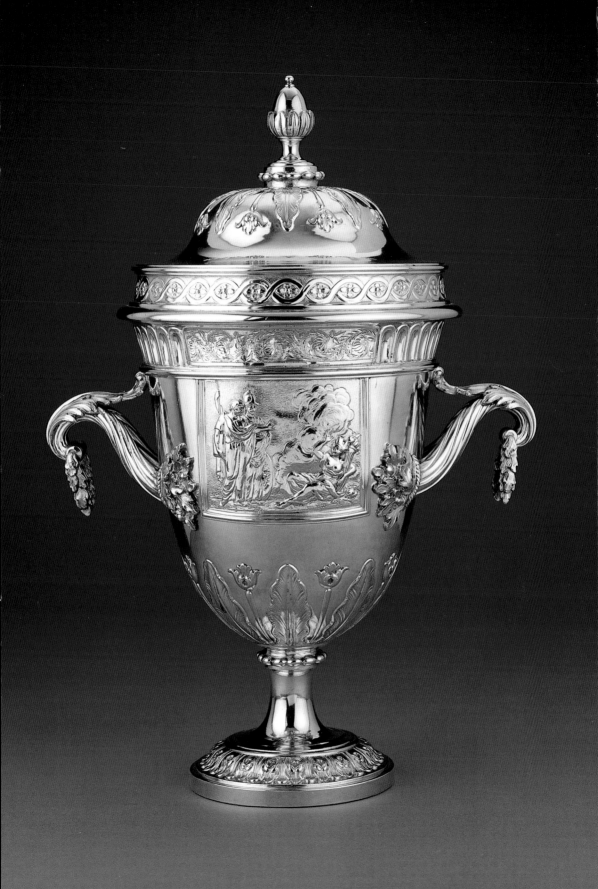

1771–72 a set of, probably, eight candlesticks to which the two in the collection once belonged (B1); they are in the form of Corinthian columns on plinths ornamented with rams' heads, festoons, swags and oval medallions. The fox-mask stirrup-cup of 1773–74 (D5), realistically chased, is a surprising product of Neoclassical taste, its design being perhaps an adaptation of the Greek *rhyton* or drinking horn. The form first appeared in the 1760s, although the term 'stirrup cup' was in use at least since the 1680s with reference to the drink taken when mounted, with feet in the stirrups ready for departure – in this case evidently for the fox hunt. A pair of sauce tureens (B15) of the following year are austerely elegant; ornament is principally confined to reeding which accentuates the fashionable attenuated loop handles.

In two successive years, 1772–73 and 1773–74, Louisa and George produced a hot-water urn and a teapot (S8, S13) which, were it not for their different crests, would seem to belong to the same set; making allowance for differing form and scale, their decorative devices are identical, and one may speculate on the existence of a successful line in tea equipment of this design. Their vase forms are ornamented with fluting and beading, embossed leaf-festoons and ribbons, bud finials and prominent acanthus leaves, employed with especial elegance to form the handles of the urn. To fulfil its particular requirements, this stands on a square base and has additional medallions and a spigot with an ivory tap and animal-mask spout; its stamped-leather fitted case also survives in the collection.

The most important by far of Louisa and George's silverware in this collection are two pieces associated with Chambers and Adam respectively. The unusual two-handled cup of 1770–71 (B10) is of special importance in its setting in one of the Fine Rooms of Somerset House, since its design is firmly attributed to Sir William Chambers, also responsible for the design of other objects of the same period in the room, Matthew Boulton's ormolu King's Clock and the Gower House Table. The architect's silver designs, typically sculptural and displaying French influence, date from the late 1760s and early 1770s. Louisa and George's cup is ascribed to him on the basis of its similarity to communion plate designed by Chambers for the Duke of Marlborough, dated for 1769–70 and still at Blenheim.

Silver designed by the royal architect was probably commissioned personally by the patron, in this case so far unidentified. The two-handled cup is in the shape of an antique *krater* or wine-mixing urn; its handles are formed by intertwining cornucopiae, evoking Plenty; around the bowl and the cover with its acorn finial are calyces of palm leaves and acanthus buds, as on the Blenheim chalice. On one side is an 'antique' tablet with a Homeric subject, representing an episode in the Trojan War when Athena (Minerva) descends to restrain Achilles from quarrelling with Agamemnon; she thereby preserves Peace, in the shape of the reclining Ceres. The standing figure holding a book reinforces Minerva's status as goddess of Wisdom. The tablet is crowned by a panel of bright-cut (see p. 8) laurels among foliage possibly inserted slightly later over the ribbon of flutes encircling the rim. French and Piranesian prints have been identified as sources, but the designer of the cast relief and its chaser are as yet unknown. On the other side of the cup a hand, perhaps the Hand of God, emerges from clouds, apparently holding in balance three veil-draped escutcheons. The armorials have been erased and one can only speculate on a possible commission from the 4th Duke of Marlborough.

Comparable in importance to this piece, in both design and associations, is the condiment vase of 1771–72 (D3). It is of *lebes gamikos* (marriage bowl) form with flying loop handles flanked by bosses, a tall finial and gadrooned borders, but its principal decoration, exceptional for the time, is the continuous engraved scene of warriors in a landscape, with Greek

B10 Cup and cover, reverse (detail), Louisa and George, 1770–71

key and anthemion borders, evidently emulating Greek vase-painting. The silver vase is identifiable as the taller central container, intended for sugar, belonging to a set of three, of which one flanking piece survives, for mustard or for pepper, also with the Birch armorials (a third surviving vase, while similar, is engraved in a different manner). Unlike the taller container the flanking piece still has its pierced ladle and suspension hook on its handle. The engraver's source and subject, perhaps relating to British Roman history, is unknown, but the vase shape is found in d'Hancarville's publication of Hamilton's Greek vases.

The set is of identical form and date as Louisa and George's more famous three condiment vases, similarly engraved, commissioned for Kedleston Hall (now Museum of Fine Arts, Boston). Robert Adam was largely responsible for the Derbyshire home of Nathaniel Curzon, 1st Baron Scarsdale, a learned patron who took close interest in every aspect of the work, which bore Adam's imprint down to the smallest detail of interior design, including the display of silver. By 1771 Adam had completed the interior but Curzon may have consulted the architect over his condiment vases, for all of which the sources appear to be d'Hancarville's prints.

The form of the Kedleston vases was sufficiently important to have been copied by Louisa and George in the same year for Charles Birch, and even appears to have influenced Wedgwood: while the potter's famous First Day Vase of 1769 is similar although less elegant in shape, he later produced a number of vases closely following the silver prototype. The Kedleston accounts prove that Louisa and

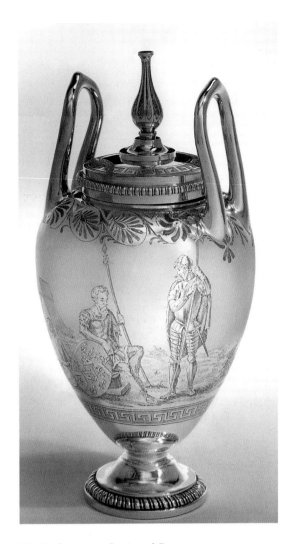

D3 Condiment vase, Louisa and George, 1771–72

George supplied quantities of silver for Curzon during the 1770s.

Crowning the collection is its latest piece, Louisa and Samuel II's large silver-gilt two-handled cup of 1778–79 (B11). Gilding was rarely used on silver in the second half of the century and here underlines the importance of this commission for John Fitzgibbon, Lord Chancellor of Ireland. The oviform vase-shape, loop handles and choice of ornament is in the style of Adam, whose name is synonymous with Neoclassicism in Britain.

Augustin's table

Silver for hot drinks and about the house

1710–1751

Everything on this table carries one of the three marks of Augustin Courtauld (1685/6–1751; see p. 5), except the chest containing tea canisters and sugar box, with the mark of Samuel Courtauld (1720–1765; see p. 6).

A1 Basket
Augustin Courtauld (3), 1745–46
Raised, chased, saw pierced, cast, soldered and engraved
27 × 35.5 × 32.1 cm; 2052 g (65.95 oz.)
Contemporary coat of arms and crest of Skottowe of Norwich impaling Palmer, possibly for John Skottowe, Governor of St Helena (died 1786); crest on handle
LO.1990.CS.101
See pages 24, 31, 34*

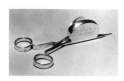

A2 Candle snuffers
Augustin Courtauld (1), Britannia, 1715–16
Cast, soldered and engraved, with two inset steel cutting edges
3.1 × 14.7 × 5.2 cm; 101 g (3.25 oz.)
Inscribed on box *A Gift for ye Use of the Chapel*
LO.1990.CS.2401
See pages 4*, 18, 29*

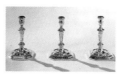

A3 Candlesticks
Three
Augustin Courtauld (1), Britannia, 1715–16
Cast, soldered and engraved
15.1 × 9.6 cm; 398 g (12.8 oz.), 396 g (12.7 oz.), 394 g (12.65 oz.)
Later coats of arms, unidentified
LO.1990.CS.503
See page 18

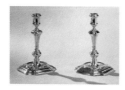

A4 Candlesticks
A pair
Augustin Courtauld (1), Britannia, 1727–28
Cast, soldered and engraved
17 × 10.9 cm; 480 g (15.45 oz.), 460 g (14.8 oz.)
Crests possibly of Sunnybanck (see S1) under each base
LO.1990.CS.505
See page 18

A5 Candlesticks
A pair
Augustin Courtauld (2), 1733–34
Cast, soldered and engraved
17.1 × 10.9 cm; 468 g (15.05 oz.), 461 g

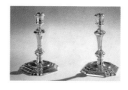

(14.85 oz.)
Later crests of Ogilvy or Plomer on each well
LO.1990.CS.506
See page 18

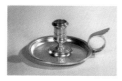

A6 Chamber candlestick
Augustin Courtauld (1), Britannia, 1710–11
Cast, forged, soldered and engraved
5.8 × 14.2 × diam. 11.5 cm; 249 g (8 oz.)
Unidentified coat of arms beneath Baron's coronet; *No. 10* under base
LO.1990.CS.501
See pages 18, 19*, 28, 29*

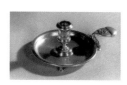

A7 Chamber candlestick
Augustin Courtauld (1), Britannia, 1711–12
Cast and soldered
5.9 × 15.5 × diam. 11.5 cm; 305 g (9.8 oz.)
Later applied gold-coloured metal monogram on handle *ELW*
LO.1990.CS.502
See pages 18, 28

A8 Chocolate pot
Augustin Courtauld (1), Britannia, 1723–24
Raised, cast, soldered and engraved; wooden handle
22.8 × 16.9 ×

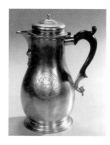

diam. 11.7 cm; 901 g (28.95 oz.)
Engraved later in contemporary style with arms of Whitchurch on one side
LO.1990.CS.701
See pages 14, 15*, 29*, 31

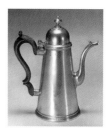

A9 Coffee pot
Augustin Courtauld (1), Britannia, 1713–14
Seamed sheet, raised, cast and soldered; wooden handle
23.2 × 20.1 × diam. 11.2 cm; 657 g (21.1 oz.)
LO.1990.CS.801
See pages 12, 28*, 31

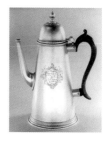

A10 Coffee pot
Augustin Courtauld (1), Britannia, 1720–21
Seamed sheet, raised, cast, soldered and engraved; wooden handle

24.7 × 19 × diam. 11.2 cm;
936 g (30.1 oz.)
Later coat of arms possibly
of West quartering
Cantelupe on one side;
crest and motto of Barlow
on the other
On base *To Samuel Baylie
Esqr: Sheriff of Worcestor
Anno:1720*
LO.1990.CS.802
See pages 12, 31

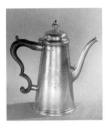

A11 Coffee pot
Augustin Courtauld (1),
Britannia, 1727–28
Seamed sheet, raised, cast,
soldered and engraved;
wooden handle
19.5 × 19.4 × diam. 9.8 cm;
591 g (19 oz.)
Script initials *JS* within
cartouche on the side
LO.1990.CS.803
See pages 12, 31

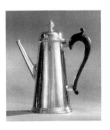

A12 Coffee pot
Augustin Courtauld (1),
Britannia, 1730–31
Seamed sheet, raised, cast,
soldered; wooden handle
21.7 × 19.5 ×
diam. 10.7 cm; 276 g
(23.35 oz.)
LO.1990.CS.804
See pages 12, 31

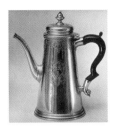

A13 Coffee pot
Augustin Courtauld (2),
1732–33
Seamed sheet, raised, cast,
soldered and engraved;
wooden handle
20.4 × 18 × diam. 10.3 cm;
660 g (21.2 oz.)
Lozenge of arms on each
side of Wall of Preston
with Colbatch in pretence,
probably for John Wall of
St Martin in the Fields and
his wife Ann Colbatch,
married 1 January 1731/32
at St Benet's, Paul's Wharf
LO.1990.CS.805
See pages 12, 26*, 29*, 31

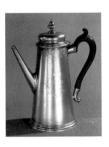

A14 Coffee pot
Augustin Courtauld (2),
1732–33
Seamed sheet, raised, cast,
soldered and engraved;
wooden handle
21.7 × 19 × diam. 10.6 cm;
743 g (23.9 oz.)
Coat of arms on one side of
Sir Thomas Hankey,
alderman, of London and
Fitcham Park, Surrey, and
his wife Sarah, daughter of
Sir John Barnard, Lord
Mayor of London 1738; his
crest on the other side
LO.1990.CS.806
See pages 12, 26, 27, 31

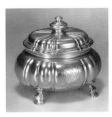

A15 Sugar box
Augustin Courtauld (2),
1737–38
Cast and soldered
10.5 × 12.4 × 10.6 cm;
560 g (18 oz.)
Coat of arms on one side of
Sir Caesar Hawkins of
Kelston, Somerset,
Sergeant-Surgeon to
George II and III; impaling
those for his wife Sarah,
daughter of John Coxe,
Esq.; crest on the other
side engraved later
LO.1990.CS.401
See pages 16, 17*, 27, 29*, 31

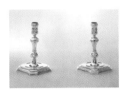

A16 Tapersticks
a pair
Augustin Courtauld (1),
Britannia, 1718–19
Cast, soldered and
engraved
9.9 × 7.9 cm; 112 g
(3.6 oz.), 126 g (4.05 oz.)
Crests in each well,
unidentified
LO.1990.CS.504
See page 9*, 19

A17 Tea canister
Augustin Courtauld (1),
Britannia, 1725–26

Seamed sheet, cast,
soldered and engraved
10.9 × 7.5 cm; 443 g
(14.25 oz.)
Coat of arms on front of
Pitches quartering possibly
Broke
LO.1990.CS.2602
See pages 16, 29*, 31

A18 Two tea canisters and a sugar box
Samuel Courtauld (1),
1750–51
Twelve teaspoons marked
FH (Francis Harache?),
tea chest, fitted and
shagreen-covered, with
silver mounts
Containers: raised, embossed,
cast, soldered and engraved
Tea canisters: 13.7 × diam.
8.7 cm; 224 g (7.2 oz.);
219 g (7.05 oz.)
Sugar box: 13.7 × 12.1 × 10.5
cm; 379 g (12.2 oz.)
Spoons: 11.2 cm; 157 g
(5.05 oz.); chest: 19.2 ×
30.8 × 16.1 cm
Coats of arms, unidentified,
on canisters, sugar box and
chest; crest on each spoon
LO.1990.CS.2604
See pages 13*, 15, 16, 34

A19 Waiters
A pair
Augustin Courtauld (1),
Britannia, 1727–28
Set flat, cast and soldered
2.3 × diam. 15.5 cm; 348 g
(11.2 oz.); 345 g (11.1 oz.)
LO.1990.CS.1904
See page 20

Samuel and Louisa's table
Silver for hot drinks and about the house
1748–1774

Everything on this table carries one of the marks of Samuel Courtauld 1 (1720–1765) or Louisa Courtauld (*ca*.1730–1807) or Louisa Courtauld and George Cowles (died 1811; see pp. 6–7).

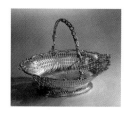

s1 Basket
Louisa Courtauld and George Cowles, 1771–72
Raised, chased, saw pierced, chased, soldered and engraved
28.6 × 40.5 × 33.5 cm; 1768 g (56.85 oz.)
Contemporary coat of arms of Sunnybanck in centre (see also A4)
LO.1990.CS.102
See pages 24, 35

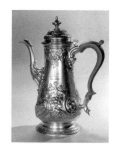

s3 Coffee pot
Samuel Courtauld (1), 1757–58
Formed from raised collar, raised, cast, soldered, embossed and engraved; wooden handle
27.6 × 22 × diam. 12.2 cm; 1031 g (33.15 oz.)
Contemporary crest on each side, unidentified
LO.1990.CS.811
See pages 12, 34

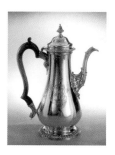

s5 Coffee pot
Samuel Courtauld (1), 1761–62
Formed from raised collar, cast, soldered and engraved; wooden handle
28 × 22 × diam. 12 cm; 976 g (31.4 oz.)
Contemporary coat of arms, unidentified
LO.1990.CS.813
See pages 12, 34

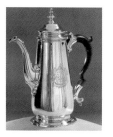

s2 Coffee pot
Samuel Courtauld (1), 1750–51
Formed from seamed collar, raised, cast, soldered and engraved; wooden handle
23 × 19.8 × diam. 10 cm; 763 g (24.55 oz.)
Contemporary coat of arms on one side of Pearce impaling either Hoskins, Hochtkis, Suwardby or Noble
LO.1990.CS.809
See pages 12, 34

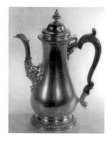

s4 Coffee pot
Samuel Courtauld (1), 1760–61
Raised, cast, soldered and engraved; wooden handle (replacement)
26.5 × 20.4 × diam. 11.5 cm; 991 g (31.85 oz.)
Initials *I.D* under base
LO.1998.CS.812
See pages 12, 34

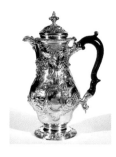

s6 Hot-water jug or Turkish coffee pot
Samuel Courtauld (1), 1758–59
Raised, cast, soldered, embossed and engraved
25.9 × 17.2 × diam. 11.4 cm; 817 g (26.25 oz.)
Coat of arms of Despayne (see also B1) impaling another on one side; crest on the other
LO.1998.CS.1501
See pages 12, 34

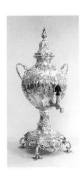

s7 Hot-water urn
(Displayed on separate plinth)
Louisa Courtauld, 1767–68
Raised, cast, soldered, embossed and engraved; wooden tap handle
58 × 30 cm; 3351 g (107.75 oz.) gross
Coat of arms above spigot of Paston of Norfolk impaling another, crests on base and cover
LO.2001.CS.1602
See pages 16, 35

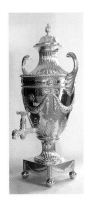

s8 Hot-water urn
(Displayed on separate plinth)
Louisa Courtauld and George Cowles, 1772–73
Raised, cast, soldered, embossed and engraved; ivory tap handle
52 × 25.5 cm; 3299 g (106.05 oz.) gross
Crest on base and cover, unidentified
LO.2001.CS.1603
See pages 11*, 16, 38

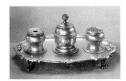

s9 Inkstand
with inkwell, pounce pot and wafer box
Samuel Courtauld (1), 1750–51
Raised, saw pierced, cast, soldered and engraved
10.8 × 26.1 × 18.7 cm; 1031 g (33.1 oz.)
Coat of arms on inkstand of Tooke or Toke quartering Fox, with unidentified arms in an escutcheon of pretence for the wife; crests of Tooke or Toke and Fox on each piece
LO.1990.CS.1401
See page 19*

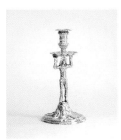

s10 Taperstick
in the form of a harlequin
Samuel Courtauld (2) 1755–56
Cast and soldered
13.5 × diam. 6.9 cm; 106 g (5.15 oz.)
LO.2001.CS.507
See pages 19, 35*

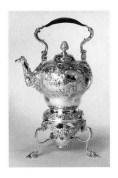

s11 Tea kettle with stand
Samuel Courtauld (1), 1748–49
Raised, cast, soldered, embossed and engraved; leather-covered handle
38.6 × 25.5 × diam. 21.5 cm; 2484 g (79.8 oz.)
Later coat of arms on one side of kettle of Sir James Hall (1761–1832) impaling those of his wife Lady Helen Douglas, daughter of 4th Earl of Selkirk (married 1786); on other side and on burner the monogram *JCH*
LO.1990.CS.1601
See pages 13*, 16, 34

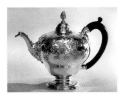

s12 Teapot
Louisa Courtauld, 1765–66
Raised, cast, soldered, embossed and engraved; wooden handle
19.5 × 26.1 × 14.8 cm; 774 g (24.9 oz.)
Crest unidentified
LO.1990.CS.2701
See pages 16*, 35

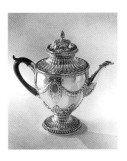

s13 Teapot
Louisa Courtauld and George Cowles, 1773–74
Raised, cast, soldered, embossed and engraved; wooden handle
23.1 × 25.5 × diam. 13.7 cm; 904 g (29.05 oz.)
Crest and motto of Wellesley-Pole, Baron Maryborough, on one side
LO.1990.CS.2702
See pages 16, 38

s14 Two tea canisters and a sugar box
Samuel Courtauld (3), 1764–65
Tea chest of veneered rosewood, fitted, with silver mounts
Containers: raised, cast, soldered and embossed
Two smaller: 15.7 × diam. 7.8 cm; 219 g (7 oz.), 207 g (6.65 oz.)
Larger: 16.4 × diam. 10.7 cm; 372 g (11.95 oz.)
LO.1998.CS.2605
See pages 16, 34

The buffet table
Silver for the dining table

Everything on this table carries one of the marks of Augustin (1685/86–1751) or Samuel Courtauld I (1720–1765), or of Louisa Courtauld (*ca.* 1730–1807) or Louisa Courtauld and George Cowles (died 1811) or Louisa Courtauld and Samuel Courtauld II (1752–1821; see pp. 5–7).

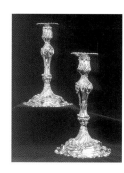

D1 Candlesticks
A pair
Louisa and Samuel Courtauld II, 1778–79
Cast, soldered, embossed and engraved
30.5 × 19.1 cm; 1257 g (40.45 oz.), 1263 g (40.6 oz.)
Crest on each base, unidentified
LO.1999.CS.509
See pages 7, 18, 35

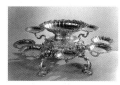

D2 Centrepiece
with eight detachable circular dishes and central oval detachable dish
Samuel Courtauld (1), 1751–52
Raised, saw pierced, embossed, cast, soldered and engraved
Stand: 25.2 × 61 × 57 cm; 3173 g (102 oz.)
Central dish: 29.8 × 23.8 cm; 749 g (24.05 oz.)
Side dishes: diam. 15.5 cm; 2936 g (94.35 oz.) total
Crest probably of Hargreaves or Roane in centre of each dish
LO.1990.CS.601
See pages 18, 22*, 23, 35

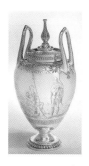

D3 Condiment vase and cover
Louisa Courtauld and George Cowles, 1771–72
Raised, cast, soldered and engraved
19.3 × diam. 9.6 cm; 407 g (13.1 oz.)
Coat of arms of Charles Birch (died 1780) of Woodford, Essex, and his wife Sarah Creed, on one of the warriors' shields, his crest on the other shield
LO.1990.CS.2901
See pages 24, 27, 38, 39*

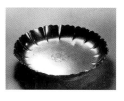

D4 Dish
Augustin Courtauld (1), Britannia, 1716–17
Raised, soldered and engraved
3.6 × diam. 19.3 cm; 481 g (15.45 oz.)
Lozenge of arms of Rear or Reade impaling another
LO.1990.CS.1101
See pages 22*, 31

D5 Fox-mask stirrup-cup
Louisa Courtauld and George Cowles, 1773–74
Raised, cast, soldered, embossed and engraved; interior gilt

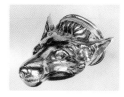

7.3 × 13.2 × 10.7 cm; 190 g (6.1 oz.)
Initials *F & F* on oval lip
LO.1990.CS.901
See pages 8*, 38

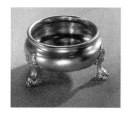

D6 Salts
A pair
Augustin Courtauld (3), 1742–43
Raised, cast and soldered; interiors gilt
4.6 × diam. 7.1 cm; 141 g (4.55 oz.), 135 g (4.35 oz.)
LO.1990.CS.1801
See pages 23, 24*, 31

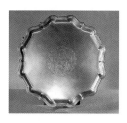

D7 Salver
Augustin Courtauld (1), Britannia, 1728–29
Set flat with raised side, cast, soldered and engraved
4.8 × diam. 41 cm; 2363 g (75.95 oz.)
Coat of arms in the centre of Berney of Norfolk quartering Delafosse
LO.1990.CS.1905
See pages 26, 30*

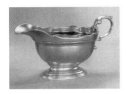

D8 Sauce boats
A pair
Augustin Courtauld (2),
1733–34
Raised, cast and soldered
10.6 × 19.8 × 10.3 cm;
459 g (14.75 oz.), 467 g
(15 oz.)
LO.1990.CS.2001
See pages 23*, 31

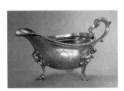

D9 Sauce boats
A pair
Samuel Courtauld (1),
1750–51
Raised, cast, soldered and
engraved
12.5 × 22 × 11 cm; 529 g
(17 oz.), 538 g (17.3 oz.)
Later coat of arms on the
sides of Robert Hankey
impaling possibly Panton
LO.1990.CS.2002
See pages 23, 35

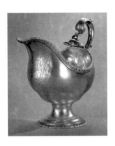

D10 Sauce boats
Set of four
Samuel Courtauld (3),
1764–65
Raised, cast, soldered and
engraved
16.5 × 17.1 × 9.9 cm; 475 g
(15.25 oz.), 471 g
(15.15 oz.), 467 g (15 oz.),
461 g (14.85 oz.)

Coat of arms possibly of
Elliot on the front of each
piece
LO.1990.CS.2004
See pages 23, 35

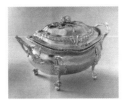

D11 Sauce tureens and covers
Set of four
Louisa Courtauld and
George Cowles, 1768–69
Raised, cast, soldered and
engraved
13 × 21.7 × 11.7 cm; 693 g
(22.25 oz.), 678 g
(21.8 oz.), 673 g (21.65 oz.),
655 g (21.05 oz.)
Coat of arms of Samuel
Crompton, High Sheriff of
Derbyshire (1768), and his
wife Elizabeth, daughter of
Samuel Fox, on one side of
each tureen, crest on the
other; crest on each cover
LO.1990.CS.2101
See pages 23, 35

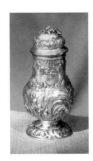

D12 Spice canister
Samuel Courtauld (1)
1750–51
Raised, cast, soldered and
embossed
12.5 × diam. 6.2 cm; 235 g
(7.55 oz.)
LO.1998.CS.26.03
See pages 6*, 24, 33*, 35

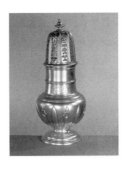

D13 Sugar caster
Augustin Courtauld (1),
Britannia, 1721–22
Raised, cast, soldered and
engraved
19.3 × diam. 8.5 cm; 465 g
(14.95 oz.)
Later crest on the side,
unidentified
LO.1990.CS.2301
See pages 24, 31*

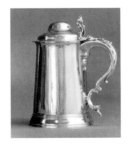

D14 Tankard and cover
Louisa Courtauld and
George Cowles, 1774–75
Raised, cast, soldered and
engraved
19.2 × 17 × diam. 12.1 cm;
904 g (29.1 oz.)
Initials *NC* and *G C to C F*
on base
LO.1990.CS.2501
See page 17

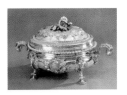

D15 Tureen and cover
Samuel Courtauld (1),
1751–52
Raised, cast, soldered,
embossed and engraved
24 × 44.6 × 24.5 cm; 4085 g
(131.35 oz.)
Coat of arms of Campe of
London on one side,
probably (though without
entitlement) for 'Captain
Camp of the Streights
Trade' and his wife 'Mrs
Charlton of Stratford with
£12,000', married 1747;
crest on the other side
LO.1990. CS.2201
See cover* and pages 2*,
23, 35

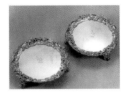

D16 Waiters
A pair
Samuel Courtauld (1),
1761–62
Flat discs set into cast
borders, feet cast and
soldered
3.7 × diam. 17.2 cm; 377 g
(12.15 oz.); 370 g
(11.85 oz.)
Crests possibly of
Chapman in the centre
LO. 1990.CS.1907
See page 20

The buffet shelves
Silver for dining and display

Everything on these shelves carries one of the marks of Augustin Courtauld (1685/86–1751) or Louisa Courtauld (*ca.* 1730–1807) or Louisa Courtauld and George Cowles (died 1811) or Louisa Courtauld and Samuel Courtauld II (1752–1821; see pp. 5–7).

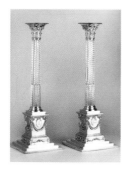

B1 Candlesticks
A pair
Louisa Courtauld and George Cowles, over-striking an unidentified mark, 1771–72
Sheet silver over wooden inserts (bases), cast, soldered, chased, pierced and engraved
37.4 × 13 × 13 cm; loaded with wooden bases
Coats of arms and crests of Giles of Bowden, Devon, impaling possibly Despayne, alternating on oval plaques on bases, different crests on removable sconces
LO.1998.CS.508
See pages 18*, 38

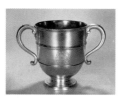

B2 Cup
Augustin Courtauld (1), Britannia, 1713–14
Raised, cast, soldered and engraved
18.2 × 26.3 × diam. 15.7 cm; 1211 g (38.9 oz.)
Later coat of arms on the front, unidentified
LO.1990.CS.1001
See pages 25, 28, 30

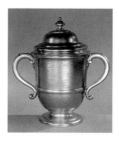

B3 Cup and cover
Augustin Courtauld (1), Britannia, 1714–15
Raised, cast, soldered and engraved
26.6 × 25.6 × diam. 15.5 cm; 1707 g (54.9 oz.)
Latin inscription: 'To commemorate the friendship between Robert Boyle, a man of the highest distinction, and Gilbert, Bishop of Salisbury, who, as was right, ever respected his friend while he lived and after his death greatly honoured his memory. This presentation was made by Sir Robert's Executors, one of whom, Sir Henry Ashurst, offered it, while Thomas Burnet caused it to take this particular form.'
LO.1990.CS.1002
See pages 25*, 26, 30

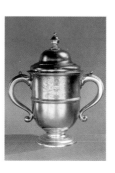

B4 Cup and cover
Augustin Courtauld (1), Britannia, 1723–24
Raised, cast, soldered and engraved
32.7 × 29.6 × diam. 17.9 cm; 2312 g (74.35 oz.)
Coat of arms on the front of Francis, 2nd Earl Godolphin (1678–1766), married 1698 Henrietta, eldest daughter of John Churchill, 1st Duke of Marlborough, from 1722 Duchess of Marlborough in her own right; crest on cover
LO.1990.CS.1003
See pages 25, 26, 30*

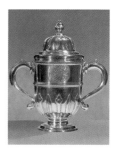

B5 Cup and cover
Augustin Courtauld (1), Britannia, 1723–24
Raised, cast, soldered and engraved; interior gilt
32.5 × 30.4 × diam. 17.2 cm; 2892 g (93 oz.)
Coat of arms on the front of Ward or Warde
LO.1990.CS.1004
See pages 25, 29, 30

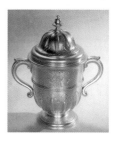

B6 Cup and cover
Augustin Courtauld (1), Britannia, 1725–26
Raised, cast, soldered, matted and engraved; interior gilt
24.6 × 21.4 × diam. 13.6 cm; 1356 g (43.6 oz.)
Coats of arms on each side of Crosse of Crosse Hall and Shaw Hill, Lancashire, possibly for Richard Crosse (1649–1742)
LO.1990.CS.1005
See pages 21*, 25, 29, 30

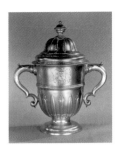

B7 Cup and cover
Augustin Courtauld (1),
overstriking an unidentified
mark, Britannia, 1731–32
Raised, cast, soldered and
engraved
31.5 × 28.1 × diam. 17.2 cm;
2670 g (85.85 oz.)
Coat of arms possibly of
Clarell or Clarrell of
Yorkshire on one side, crest
on the other; crest on cover
LO.1990.CS.1006
See pages 25, 26, 28, 29, 30

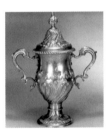

B8 Cup and cover
Louisa Courtauld, 1765–66
Raised, cast, soldered,
embossed and engraved
41.1 × 31.9 ×
diam. 16.3 cm; 2282 g
(73.4 oz.)
Contemporary coat of arms
on one side, unidentified,
crest on the other; crest on
cover
LO.1990.CS.1007
See pages 25, 35

B9 Cup and cover
Louisa Courtauld, 1765–66
Raised, cast, soldered,
embossed and engraved;
interior gilt
36.8 × 29.4 ×
diam. 15.8 cm; 1921 g
(61.75 oz.)
Later coat of arms possibly
of Grindall on one side,

crest on the other
LO.1990.CS.1008
See pages 25, 35

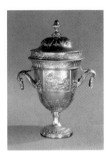

B10 Cup and cover
Louisa Courtauld and
George Cowles, 1770–71
Designed by Sir William
Chambers
Raised, cast, soldered and
chased; interior gilt
29.5 × 21 × diam. 14.7 cm;
1567 g (50.4 oz.)
LO.1990.CS.1009
pages 25, 37*, 38, 39*

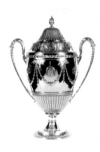

B11 Cup and cover
Silver gilt
Louisa and Samuel
Courtauld II, 1778–79
Raised, cast, soldered,
embossed and engraved,
gilt
43.8 × 32.7 ×

diam. 19.9 cm; 2957 g
(95.1 oz.)
Coats of arms of John
FitzGibbon (1749–1802),
Lord Chancellor of Ireland,
created Earl of Clare 1795,
on medallions on either
side, crests on either side of
cover
LO.1990.CS.1010
See pages 3*, 7, 25, 27

B12 Salvers
A pair
Augustin Courtauld (1),
Britannia, 1724–25
Set flat, cast, soldered and
engraved
2.5 × 24.8 cm; 784 g
(25.2 oz.), 743 g (23.9 oz.)
Coats of arms in centre of
Viscount Blundell
(1689–1756) and his wife
Mary, daughter of John
Chetwynd of Grendon,
Warwickshire, married
1709
LO.1990.CS.1901
See page 20

B13 Salver (or tray)
Augustin Courtauld (1),
Britannia, 1724–25
Flat sheet, cast, soldered
and engraved
4.2 × 46.6 × 35.9 cm;
2724 g (87.6 oz.)
Coat of arms of John, 3rd
Baron Ashburnham
(1687–1737), created Earl
1730
LO.1990.CS.2801
See pages 15, 26, 27*, 30

B14 Salver
Large
Louisa Courtauld, 1767–68
Flat sheet, set into cast,
pierced border, feet cast
and soldered, engraved
6.4 × diam. 73.3 cm; 8452 g
(271.75 oz.)
Contemporary coat of arms
of Reynolds with Carr in
pretence
LO.1998.CS.1908
See pages 15, 25, 27, 35

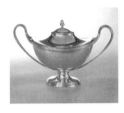

B15 Sauce tureens and
covers
A pair
Louisa Courtauld and
George Cowles, 1774–75
Raised, cast and soldered
16.3 × 25.8 × 10.8 cm;
879 g (28.25 oz.)
875 g (28.1 oz.)
Coat of arms granted 1782,
probably of Lewis Teissier
or Tessier (1736–1811) of
Woodcote Park, Surrey, on
one side of each tureen;
crest on each cover
LO.1990.CS.2102
See pages 23, 24*, 38

Further reading

Publications consulted could not all be listed here, for reasons of space. Bibliographical references in the following works lead to other works and authors to whom I am also indebted.

Antonia Agnew, David Doxey and Felicity Marno, *Tea, Trade and Tea canisters*, Stockspring Antiques, London, 2002

Brian Allen and Larissa Dukelskaya, ed., *British Art Treasures from Russian Imperial Collections in the Hermitage*, New Haven and London 1996

Claude Blair, ed., *The History of Silver*, London 1987

Helen Clifford, entries on the Courtauld family in *The Dictionary of National Biography*, forthcoming

The Courtauld Family: Huguenot Silversmiths, Goldsmiths' Hall, London, 1985

S.L. Courtauld, *The Huguenot Family of Courtauld*, 3 vols., London 1957–67

Philippa Glanville, ed., *Silver*, London 1996

Philippa Glanville and Jennifer Faulds Goldsborough, *Women Silversmiths 1685-1845. Works from the Collection of the National Museum of Women in the Arts*, Washington, D.C., 1990

Arthur G. Grimwade, *London Goldsmiths 1697-1837: Their Marks & Lives*, 3rd edn, London 1990

Leslie Campbell Hatfield, 'A Set of English Silver Condiment Vases from Kedleston Hall', in *Museum of Fine Arts, Boston, Bulletin*, LXXIX, 1981

J.F. Hayward, *The Courtauld Silver. An Introduction to the Work of the Courtauld Family of Goldsmiths*, London 1975

[E. Alfred Jones], *Some Silver wrought by the Courtauld Family of London Goldsmiths in the Eighteenth Century*, 1940

T.V. Murdoch, *Museum of London Treasury Exhibition: London Silver 1680–1780*, 1982–83

Tessa Murdoch, 'The Courtaulds: Silversmiths for Three Generations. 1708 to 1780', *Proceedings of the Silver Society*, III, no. 4, 1984, pp. 88ff.

Toby and Will Musgrave, *An Empire of Plants, People and Plants that changed the World*, London 2000

Harold Newman, *An Illustrated Dictionary of Silverware*, 1987 (paperback edition 2000)

Charles Oman, *English Engraved Silver 1150 to 1900*, London 1978

Sara Paston-Williams, *The Art of Dining. A History of Cooking & Eating*, 1993

The Quiet Conquest. The Huguenots 1685 to 1985, Museum of London, 1985

Rococo. Art and Design in Hogarth's England, Victoria and Albert Museum, London, 1984

Timothy Schroder, *The National Trust Book of English Domestic Silver 1500–1900*, London 1988

Eric J.G. Smith, 'The Courtauld Goldsmiths', I-V, *Antique Dealers' and Collectors' Guide*, February 1997– February 1998

Hilary Young, 'Sir William Chambers and the Duke of Marlborough's Silver', *Apollo*, CXXV, January 1987, pp. 396–400

Acknowledgements

My thanks are due in the first place to Akzo Nobel for their magnanimity in extending indefinitely the loan of this collection to the Courtauld Institute Gallery. Richard Parsons's association with Akzo Nobel and before that with Courtaulds plc, and his crucial rôle in the formation of this collection, is long-standing; he has shown extraordinary generosity in support of this publication, above all in sharing not only books from his library, but also his own detailed catalogue, on which indeed this publication is based. Timothy Schroder has with great kindness saved me from numerous errors of the kind every non-specialist fears; Philippa Glanville also read my typescript, and to these eminent authorities I am very much indebted, while taking full responsibility for any mistakes. Sir Adam Butler has provided me with information about his Courtauld ancestors and the present family, among whom I am particularly grateful to Julian Courtauld. The Hon. Janet Grant at the College of Arms has identified a number of engraved coats of arms. My thanks also go to David Beasley and Jane Bradley at the Library of Goldsmiths' Hall; to Diane Clements, Director of the Library and Museum of Freemasonry; to Helen Clifford and her editor Robert Brown at the Dictionary of National Biography; to Celia Fisher for identifying the flower forming the tureen's finial; to John Hardy at Christie's for important information about Louisa and George's condiment vase and the Chambers cup; to Tessa Murdoch at the Victoria and Albert Museum, and to her colleagues Richard Edgcumbe and Hilary Young for advice about the Chambers cup.

My colleagues, including Julia Blanks, Jacky Klein and Aileen Ribeiro, have provided warm support. Ernst Vegelin's unfailing encouragement was indispensable. To William Clarke in particular this publication is indebted for substantial contributions, including the investigation of coats of arms and advice on the description of techniques, and as the author of drawings on p. 8. Nigel Dickman, General Manager of SCT Enterprises, provided essential backing for this publication, for which Richard Valencia took the colour photographs. Paul Holberton oversaw the publication of this book, which has greatly benefitted from his wise counsel, imagination and experience. Kenneth Martin Leake's patient support has been all-important at every stage. HB

Produced for the Courtauld Institute Gallery by Paul Holberton publishing 37 Snowsfields London SE1 3SU www.paul-holberton.net

Designed by Roger Davies daviesdesign@onetel.net.uk

Printed in Italy

Distributed by Paul Holberton publishing through Greenhill Books, London, and University of Washington Press, Seattle